RADIO FLYER

100 YEARS
OF AMERICA'S
LITTLE RED
WAGON

· ROBERT PASIN ·

with CARLYE ADLER

HARPER
DESIGN
An Imprint of HarperCollinsPublishers

Published in 2018 by

Harper Design

An Imprint of HarperCollins*Publishers*

195 Broadway

New York, NY 10007

Tel: (212) 207-7000

Fax: (855) 746-6023

harperdesign@harpercollins.com

www.hc.com

Distributed throughout the world by

HarperCollins *Publishers*

195 Broadway

New York, NY 10007

ISBN: 9780062838995

Library of Congress Control Number: 2018941398

Book design by Raphael Geroni

Printed in China

First Printing, 2018

"For every boy. For every girl."

IN MEMORY

In memory of Antonio Pasin, who came to America more than one hundred years ago full of hope and optimism in search of a better life, and who showed us that all dreams can take flight with persistence, imagination, and love.

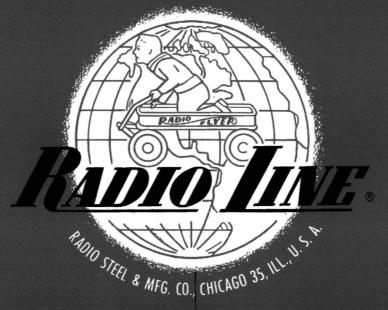

RADIO LINE ®

RADIO STEEL & MFG. CO., CHICAGO 35, ILL., U.S.A.

COASTER WAGONS *and* SCOOTERS

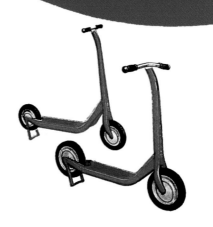

"Ride the Radio Line" ★

TABLE *of* CONTENTS

Letter *from* Chief Wagon Officer Robert Pasin

THE FIRST TIME I VISITED RADIO FLYER I was five years old. I was home from school with a broken arm, so my dad brought me to work with him. I remember that day like it was yesterday: walking into the front entrance, climbing the stairs to the second floor, looking up at the enormous image of the Coaster Boy World's Fair exhibit, walking around the office with my dad saying hello to everyone. Exploring the factory with the loud noises of punch presses and the smell of paint and seeing all of the shiny new red wagons on the conveyor line—it seemed like a magical Rube Goldberg invention, a giant machine cranking out little red wagons and sending them into the world to bring joy to millions of families. That was the day I fell in love with Radio Flyer.

I fell in love with the fact that Radio Flyer creates products that inspire active play. I fell in love with the people who work for and with Radio Flyer. Most of all, I fell in love with what Radio Flyer means to millions of its fans. It transports people to a happy place—to the best parts of childhood, moments of adventure, imagination, family, friends, sunshine, green grass, and most of all, love.

Ever since I was a child, I was equally charmed by my grandfather Antonio Pasin, the founder of Radio Flyer Inc., and the story of his life. A cabinetmaker from a small Italian village outside Venice, he came to America with nothing, and proceeded to invent the first little red wagon with little more than scraps of metal and big dreams. From this innovation, he started the Radio Flyer company, the business that has been stewarded by my family and served countless others for generations. Throughout his life, he was always happy and hardworking, with movie-star good looks and not a dishonest bone in his body. Growing up, I always thought of him as Geppetto, the gentle and delightful wood carver who created Pinocchio, because they were both skilled carpenters and craftsmen who made toys imbued with magical qualities that came to life using one's imagination.

Years later, all of these experiences led me to join my family working for Radio Flyer at a very young age, first in the

warehouse in the summertime and then in sales, where I learned from being out in the field. Speaking directly with wholesale buyers and individual customers alike showed me very early on just how important my grandfather's and father's work was to many families. Day after day, I heard countless stories of how playing with a little red wagon shaped so many childhoods. I became convinced my destiny was to carry on this legacy. Today, as CEO at Radio Flyer, a role we refer to as "Chief Wagon Officer," I have the responsibility of continuing to build Radio Flyer into a modern brand worthy of its storied past. The best part of my job is interacting with customers—hearing firsthand how our toys are being rediscovered by each new generation.

In 2017, Radio Flyer became one of very few businesses to turn one hundred years old. We created this book to capture the spirit of the past century, to explore the way the business has changed and evolved since my grandfather started it out of a one-room garage in Chicago in 1917. These pages are filled with stories of my grandfather, the evolution of Radio Flyer, our growth as a country, and tales from people all over America—Arkansas, South Dakota, Hawaii—about how Radio Flyer shaped their youth. People told us about how they rode their wagons through childhood, through parenthood, and into grandparenthood. They shared how our wagons have sparked memories of racing down suburban streets, giving a lift to a sick friend, carting around a beloved (and sometimes unwilling) pet. They revealed accounts of imagination, of love, of life.

By keeping in touch with customers and researching Radio Flyer's legacy for this book, we found people who appropriated their Radio Flyers in ways we could never expect—modeling their cars to look like Radio Flyers or converting their wagons into go-karts, monster trucks, and lawn mowers to compete over the most innovative transformations. We are awed by younger generations adapting the Radio Flyer wagon into their own modern novelties, creating flower boxes, bookshelves, clocks, coffee tables, wall hangings, and ice coolers, and sharing them on social media sites like Pinterest and Instagram.

Today, Radio Flyer remains as it was at its inception—a Chicago-based family company committed to creating beautifully designed, quality products that inspire adventures fueled by imagination, family, and fun. Over the years, we've had to transform how we thought about our brand, all while staying true to our unique legacy. We reimagined ourselves as a company that creates awesome kids' products, which include our core wagons, of course, but has also led to many new products, such as tricycles, scooters, and other ride-ons. We also launched a way for consumers to custom design their own Radio Flyer complete with seats, seatbelts, cup holders, storage, and sun protection, and personalized with the rider's name. Most recently, we partnered with Tesla—one of the oldest transportation companies with one of the newest and most visionary on the planet—to create the Tesla Model S for Kids by Radio Flyer.

We are grateful to our customers for enjoying the ride with us for the past century, and we're eager for the next hundred years of pulling, pedaling, and steering Radio Flyers wherever the imagination leads.

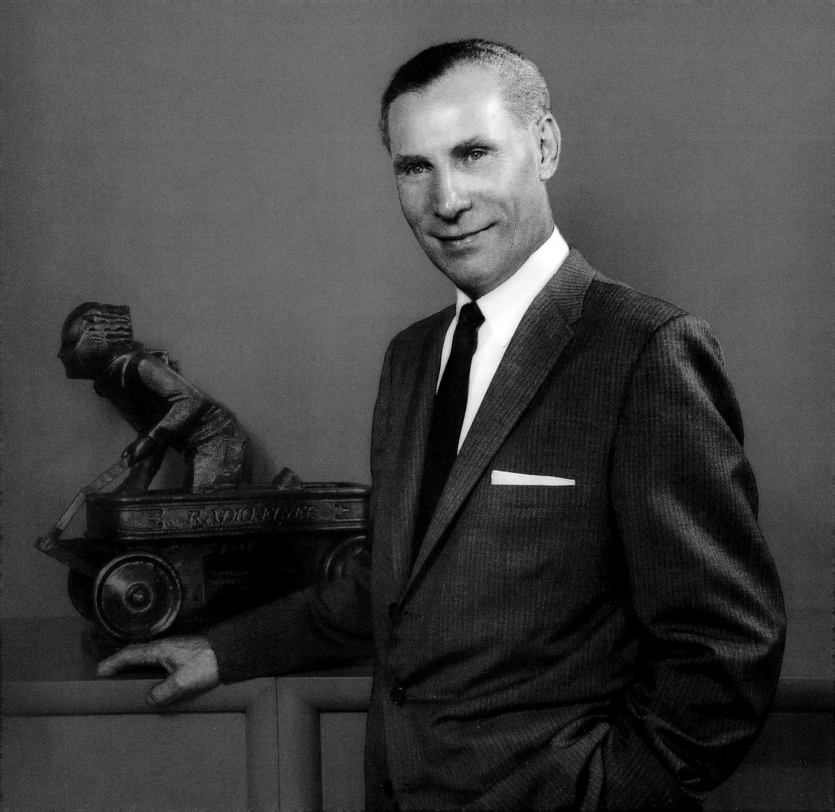

INTRODUCTION

The MAKING of an AMERICAN ICON

E VERYONE HAS A STORY ABOUT THEIR Radio Flyer—the time you took it to the moon, or raced in the Indy 500, or explored the Wild West. The story likely includes someone important: your father, your sister, your neighbor, your pet. It's the story of your childhood.

But the story behind Radio Flyer—the past hundred years that tell a tale of a family, a company, and a country—is just as captivating and memorable. It's the story of the making of an American classic. That's why when First Lady Michelle Obama needed a gift for young Prince George of England, she bought a little red wagon. Or when former secretary of state Colin Powell needed a symbol for his philanthropic endeavor America's Promise, he used a little red wagon. And when Bob Dylan needed the perfect image of nostalgic love for a song, he wrote about the little red wagon. So how is it that a product as simple as a stamped-steel wagon, with four wheels, a handle, and some red paint, became a symbol of America? The answer is in the pages of this book.

Radio Flyer was founded in 1917 by Antonio Pasin, a young Italian immigrant living in the slums of Chicago. The company he created would go on to sell more than a hundred million wagons, and grow into one of the most successful family-owned businesses and beloved brands of all time. It's hard to imagine a 1950s suburban house without a little red wagon on the lawn. One advertisement from 1973 deemed the Radio Flyer the "only wagon that outsells Ford station wagons." In *Radio Flyer: 100 Years of America's Little Red Wagon*, we will go back to the very beginning: to Italy at the cusp of the World War I, to the buzzing center of Chicago in the Roaring Twenties, through the austerities of the Great Depression and manufacturing during World War II, and on to today, as Radio Flyer faces shiny new competition, retail consolidation, and changing technology. Customers' stories and pictures are shared throughout.

Ultimately, Radio Flyer's story is America's story. With this book, readers and fans will learn for the first time not only about the brand they (and their grandparents) love, but about also our country and the opportunity it gave to enterprising immigrants, and how family ties are strong enough to build something that can last for more than a century. It will resonate with anyone who's been on a wild ride and made one of the most important discoveries: it's the unexpected journey, not the gloried destination, that is the best part.

Opposite: Founder Antonio Pasin (1897–1990) in front of a statue commemorating Radio Flyer's Coaster Boy exhibit at the 1933 Chicago World's Fair.

RADIO FLYER TIMELINE

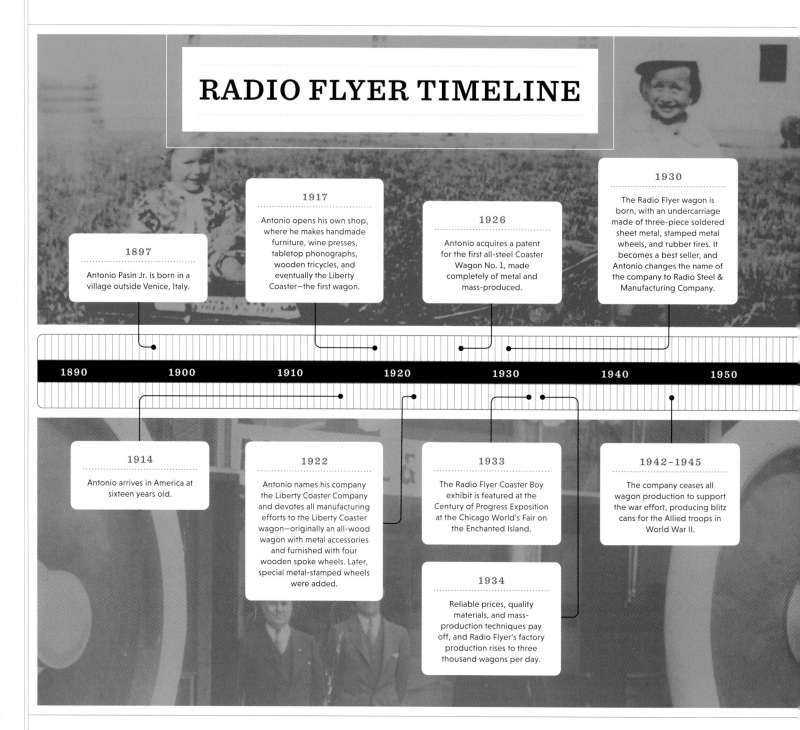

1897

Antonio Pasin Jr. is born in a village outside Venice, Italy.

1914

Antonio arrives in America at sixteen years old.

1917

Antonio opens his own shop, where he makes handmade furniture, wine presses, tabletop phonographs, wooden tricycles, and eventually the Liberty Coaster—the first wagon.

1922

Antonio names his company the Liberty Coaster Company and devotes all manufacturing efforts to the Liberty Coaster wagon—originally an all-wood wagon with metal accessories and furnished with four wooden spoke wheels. Later, special metal-stamped wheels were added.

1926

Antonio acquires a patent for the first all-steel Coaster Wagon No. 1, made completely of metal and mass-produced.

1930

The Radio Flyer wagon is born, with an undercarriage made of three-piece soldered sheet metal, stamped metal wheels, and rubber tires. It becomes a best seller, and Antonio changes the name of the company to Radio Steel & Manufacturing Company.

1933

The Radio Flyer Coaster Boy exhibit is featured at the Century of Progress Exposition at the Chicago World's Fair on the Enchanted Island.

1934

Reliable prices, quality materials, and mass-production techniques pay off, and Radio Flyer's factory production rises to three thousand wagons per day.

1942–1945

The company ceases all wagon production to support the war effort, producing blitz cans for the Allied troops in World War II.

1890 1900 1910 1920 1930 1940 1950

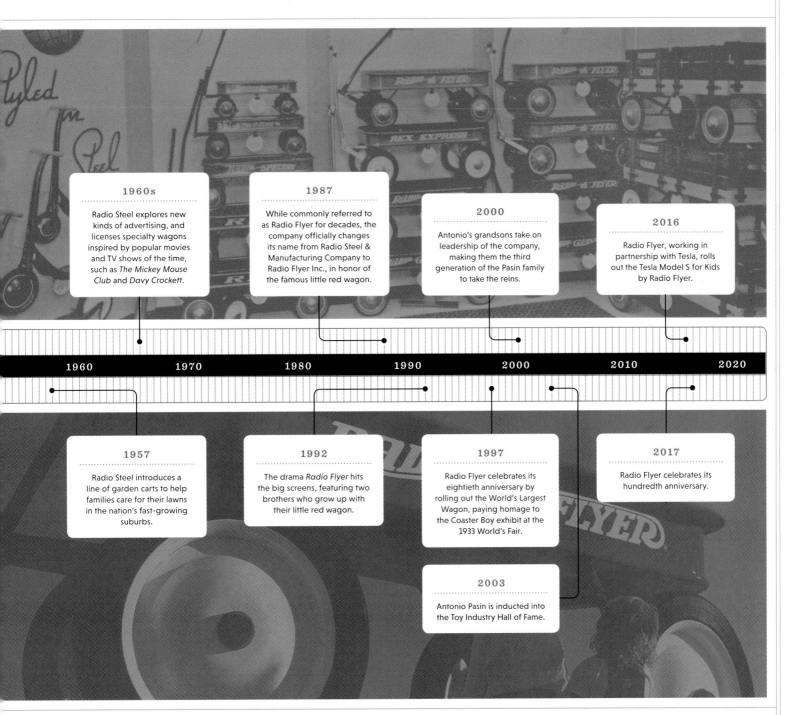

1960s

Radio Steel explores new kinds of advertising, and licenses specialty wagons inspired by popular movies and TV shows of the time, such as *The Mickey Mouse Club* and *Davy Crockett*.

1987

While commonly referred to as Radio Flyer for decades, the company officially changes its name from Radio Steel & Manufacturing Company to Radio Flyer Inc., in honor of the famous little red wagon.

2000

Antonio's grandsons take on leadership of the company, making them the third generation of the Pasin family to take the reins.

2016

Radio Flyer, working in partnership with Tesla, rolls out the Tesla Model S for Kids by Radio Flyer.

1960 1970 1980 1990 2000 2010 2020

1957

Radio Steel introduces a line of garden carts to help families care for their lawns in the nation's fast-growing suburbs.

1992

The drama *Radio Flyer* hits the big screens, featuring two brothers who grow up with their little red wagon.

1997

Radio Flyer celebrates its eightieth anniversary by rolling out the World's Largest Wagon, paying homage to the Coaster Boy exhibit at the 1933 World's Fair.

2017

Radio Flyer celebrates its hundredth anniversary.

2003

Antonio Pasin is inducted into the Toy Industry Hall of Fame.

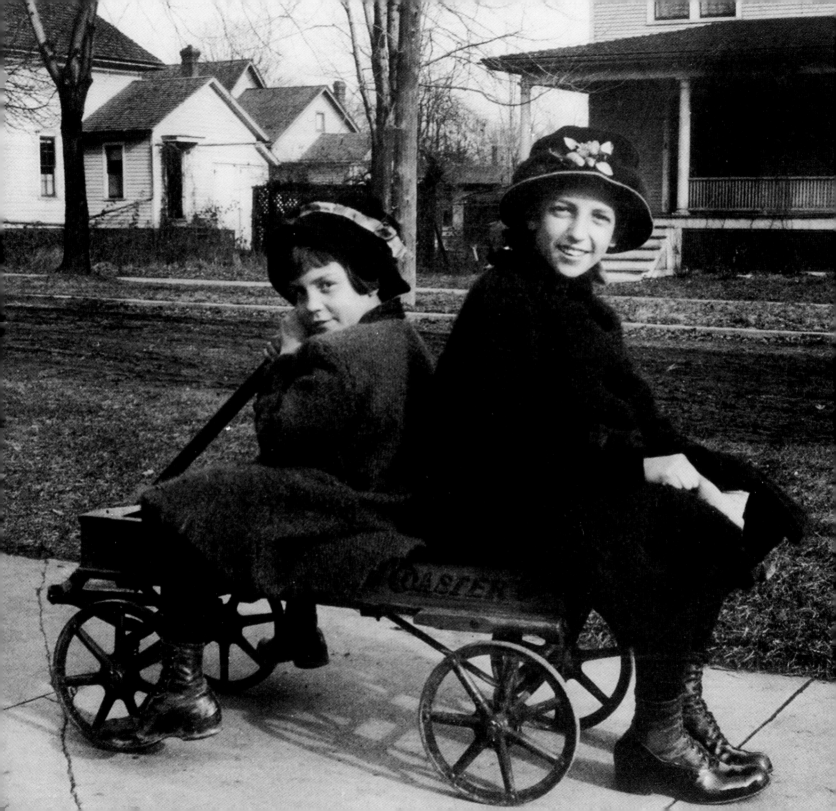

The BIRTH of the WAGON

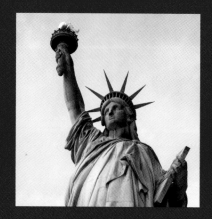

ANTONIO PASIN'S STORY OF coming to America starts where most of those who came to this country with nothing but a dream start— on a boat, crowded against the rails of the lower deck, where passengers could just barely see the Statue of Liberty's green robe and flame ablaze against the city's gray skyline. Antonio had left his family and home village outside of Venice, Italy, to set out for the faraway land of America on his own. He promised himself he would return after he had made enough money to buy back his family's home. He was sixteen years old.

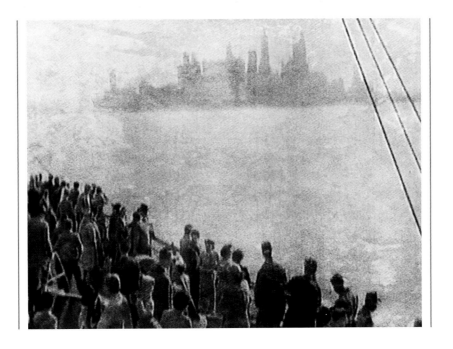

ANTONIO BOARDED AS ONE OF THE third-class steerage passengers on a ship named the *Cleveland*, which set out from Genoa, Italy, in the spring of 1914 and docked about two weeks later in New York—the city that was rumored to be the "Capital of the World." The date of Antonio Pasin's arrival is recorded in the Ellis Island passenger logs as April 19, 1914, exactly three months, one week, and two days before the start of World War I. Fleeing the political turmoil and poverty of many European states at the turn of the twentieth century, some fifteen million Europeans arrived on America's shores leading up to the war—more than three million of which were Italian, making them the largest group of new immigrants to America. In time, they would bring us pizza, blue jeans (an Italian textile invention, not an American one), Yogi Berra, Frank Sinatra—and the little red wagon.

After passing through Ellis Island, Antonio boarded a train headed to Chicago. Overall, the journey from Italy into the heart of America took about twenty days, but the only thing Antonio would ever talk about was that moment he saw the Statue of Liberty. He would later name the first wagon he built the Liberty Coaster, after "Lady Liberty"—the first face to greet him when he landed on America's shores.

Above and Opposite: The Statue of Liberty welcomed more than twelve million immigrants to America's shores between 1900 and 1954. Immigrants would pass by "Lady Liberty," then go through inspection on Ellis Island before settling in New York, Chicago, or one of America's other bustling cities.

17

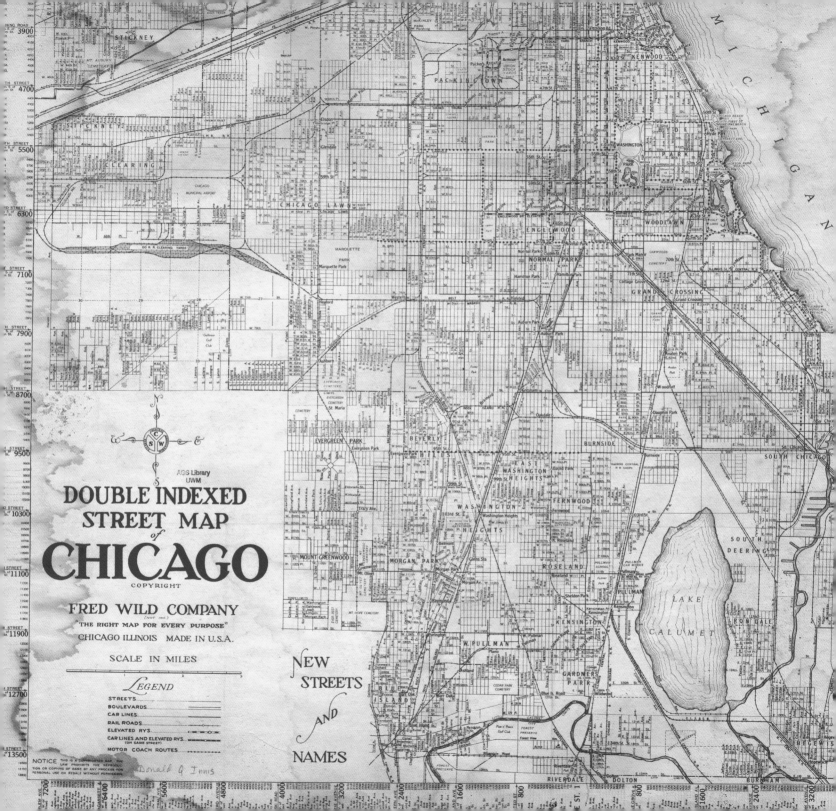

DOUBLE INDEXED
STREET MAP
of
CHICAGO
COPYRIGHT

FRED WILD COMPANY
(NOT INC.)
"THE RIGHT MAP FOR EVERY PURPOSE"
CHICAGO ILLINOIS MADE IN U.S.A.

SCALE IN MILES

NEW
STREETS
AND
NAMES

LEGEND

STREETS
BOULEVARDS
CAR LINES
RAIL ROADS
ELEVATED RYS.
CAR LINES AND ELEVATED RYS.
(ON SAME STREET)
MOTOR COACH ROUTES

NOTICE THIS IS A COPYRIGHTED MAP. THE
LAW PROHIBITS THE REPRODUC-
TION OR COPYING OF SAME BY ANY PROCESS FOR
PERSONAL USE OR RESALE WITHOUT PERMISSION.

Donald Q. Innis

CHICAGO'S LITTLE ITALIES

THE CHICAGO THAT ANTONIO PASIN arrived at in 1914 was a place filled with the raw realities of industry and overpopulation. The city had more than a dozen Little Italies, creating a map across the city that replicated the same regional divisions that had existed in the home country, as workers accumulated savings to send to their relatives back there. Southern Italians gathered in "Little Sicily" on the North Side of the city, most Tuscans came together in the "Heart of Italy" on the city's Lower West Side, and people from northern Italy, including Antonio, settled in "Little Venice" on the West Side of the city. Every community had its own heritage, and gradually these neighborhoods became famous for their vibrant culture, food, and dancing.

Like most immigrant laborers who were new to the city, Antonio lived in a boardinghouse. It was near West Grand Avenue, where he could walk to the nearby industrial areas of the city to look for work. It was common for boardinghouses to double their capacity by assigning two workers to a bed to sleep "hot bed" shifts, alternating between their day and night labor schedules.

Work was often the only common factor among these new residents of Chicago's Italian communities. Italian labor contractors, called *padrones,* acted as middlemen to find newcomers work and broker deals. Many of them were fair, and many of them were not. But without any formalized unions or connections beyond whatever family members had come over with them, most Italian peasants, or *paesani,* had little choice. The padrones shipped workers seemingly at random to construction sites all across the city, primarily to work on massive public works projects.

> *"The boardinghouse felt like a human beehive. One was a poor man among the poor. The meals were poor, and we mostly waited around learning to pronounce the English word 'work.'"*
>
> — ANTONIO PASIN

Opposite: A map of the city of Chicago circa 1920.

Previous craftsmen who had been trained as artisan masons and woodworkers took jobs as bricklayers and railroad track layers.

Antonio's first job was carrying water for a sewer-digging crew. His next job was for a railroad company, where he was employed to carry wooden crossbars to the farthest extremities of new tracks reaching out from the city's central nervous system. Immigrant work was primarily subterranean, and Anto-

years old, he was too young and they were not looking for any apprentices. It also didn't help that he did not speak English. But now that Antonio had seen the inside of the factory, which reminded him of working in his father's woodshop in Italy, he saw the possibility he was hoping for and did not back down. He bought an Italian-English grammar book and began to study in the evenings, smudging the pages with his dirty fingers and

> *"Before I came to America, I thought the streets were paved in gold. When I came here I learned three things: The streets were not paved in gold, the streets weren't paved at all, and I was expected to pave them."*
>
> ·····························
>
> —ITALIAN IMMIGRANT CIRCA 1915

nio began working in the depths of the city's factories, sending his wages home to his parents to help them to buy back the family home. He described this time in his journal as "bestial" and "with minimal pay." Indeed, the average annual salary for Chicago's immigrant workers at the time was about $650, equivalent to $16,000 in today's dollars.

Antonio passed an American piano factory every day on his way to work. One day he got up the courage to go in, hoping he would be given the opportunity to show off his woodworking skills. The owners quickly dismissed him; still only seventeen

practicing writing his rudimentary vocabulary in the margins. He studied relentlessly the phrases he needed to make himself understood and returned to the piano factory to ask for a job. The owner of the factory hired him as an assistant in charge of the circular saws. This was Antonio Pasin's first small triumph—pulling himself out of the tunnels and into the light of day by his own initiative. It was also his first lesson in what it would take to make it in America—not only hard work, but the willingness to take a risk, which would serve him as he prepared to set out on his own.

A **LETTER** *from* **HOME**

FOR ALMOST TWO YEARS, ANTONIO WORKED HARD AT EVERY JOB HE held, sending whatever remained of his wages each month to his family to help them buy back their home, which they had lost. Sometime in 1916, Antonio received this letter:

> Dear Son,
>
> We're all fine here and we hope you are too. We think of you always and we all really want to see you. I have always had faith in you, but you have surpassed all expectations.
>
> I have bought our old house and I've had it remodeled like new even using your rocks and sand. You knew the day would come—and it's a beautiful day. The special trees you had planted before you left have grown tall and beautiful . . .
>
> Your Loving Father

Antonio, now eighteen years old, cried when he read the letter. He described it in his journal as "the letter of victory." He would not be permitted to return to Italy until after the Great War was over in 1918. But he had tasted what was possible in America—that if you worked hard and had initiative, then you would get the opportunities you needed to make it—and knew then that he would not return home when the war finally ended. He still had to make a name for himself in America.

Above: The beginning of the first letter Antonio received from his father in Italy. Before he left home, Antonio planted several trees outside of the house as a promise that he would eventually return to see them fully grown. *Right:* The cover of Antonio's 1950 unpublished manuscript, titled *Appunti Sulla Vita D'Un Emigrante* ("Notes on the Life of an Immigrant").

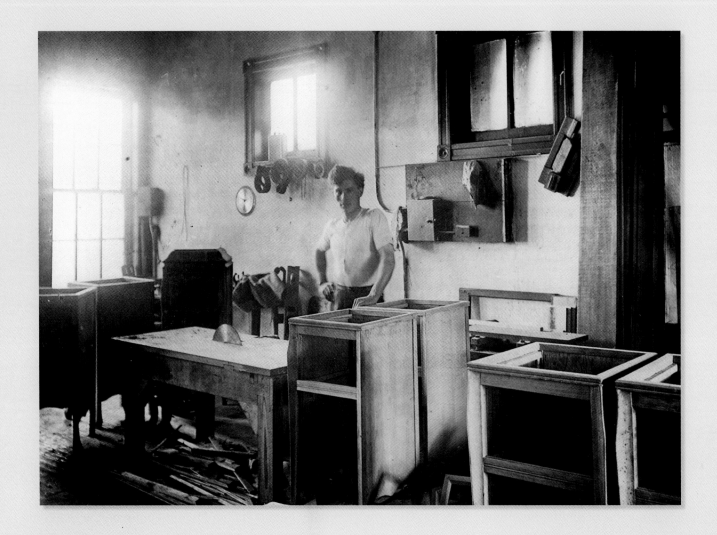

ANTONIO'S FIRST GARAGE
&
EARLY PRODUCTS

BY 1917, ANTONIO HAD SAVED A BIT of money—enough money to leave the piano factory and start his own workshop. At the same time, Chicago was adapting to a two-thirds increase in its population. Alexander Graham Bell was making his famous call across the country to Thomas Watson in San Francisco, inaugurating the first transcontinental phone service. Einstein was formulating his theory of general relativity. The American economy appeared to be setting out on a whole new era of innovation and consumption. America's GDP grew 26 percent between 1910 and 1925.

Antonio was inspired by the leaps of innovation that were being made all over the country and decided to take his first entrepreneurial risk. He took all of his savings and rented a one-room garage on West Grand Avenue. He built a table that he placed in the middle of the room, bought some tools he kept in a box at his feet, and set about building a business.

The garage was run-down but it was filled with light, and Antonio

Above: An example of the kind of wooden phonograph cabinet Antonio made for his clients. *Opposite:* Antonio at his working table inside the first one-room garage he rented, originally using his woodworking skills to fashion handmade furniture, wine presses, and phonographs.

loved the little space as it gradually filled with wood pieces and carefully kept tools. It was customary among Italians in America to make their own wine, pressing the grapes at home, and Antonio decided his first creation would be a wine press made out of wood that was designed to perfectly crush and strain grapes that had already been pressed and fermented by families at home. He quickly sold all 175 wine presses he'd made to Italian families across the city. When he realized he had pressed the market dry, he decided to try to create a product that would appeal to a wider market.

He started to build handmade furniture for modest families who, as wages were beginning to rise, could afford simple luxuries. Many of the families also had children, so he created a line of handmade wooden tricycles reminiscent of the wooden bicycle he first built for himself when he was only eleven years old back in his little Italian village. The furniture, tricycle, and later a series of wooden phonographs were all successful, but Antonio knew he could do better . . .

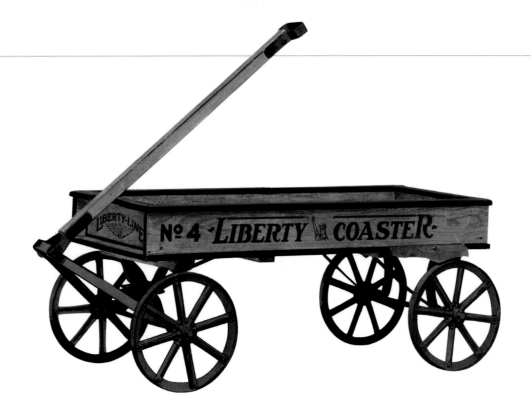

THE BIRTH OF THE WAGON

THEY SAY NECESSITY IS THE MOTHER of invention, and the little red wagon was no exception to the rule. The first wagon Antonio Pasin ever created was designed to cart around his myriad tools. To him, the wagon was purely practical, but then people started asking if he could make one like it for them to use—or even for their kids to play in! Inspired by customer demand, Antonio built a line of wooden wagons as a simple and inexpensive children's toy, designed, sawed, and sanded with his own hands.

The wagons sold as quickly as he could build them, and Antonio knew he had found his winning product. Antonio called his creation the Liberty Coaster, named for the Statue of Liberty, a manifestation of the

Above: Named for the Statue of Liberty, the Liberty Coaster wagon was Antonio's first wagon. It was made entirely of wood and had a simple, reliable design. The wagon was well received and Antonio continually modified his designs to suit customers' feedback, adding a metal handle, steel-rimmed wheels, and different size options to future models.

25

excitement he felt upon seeing it when he arrived at America's shores. He also made smaller samples of the wagon, which he carried with him in a battered suitcase to sell to local hardware stores. As the Liberty Coaster's sales grew, Antonio expanded the Liberty Line to include different-sized wagons: the Liberty Coaster, a tricycle (he called it a pedal car), and a scooter. While the Liberty Line was successful enough for Antonio to create some of his first advertisements to attract the interest of retail buyers, other wooden wagon competitors began producing at a greater scale.

Antonio decided to try something different. What if he made the entire body out of steel, which would be more durable and sleeker than wood? With that entrepreneurial epiphany he created the first all-metal coaster wagon, with stamped metal wheels and rubber tires. He decided to paint the body all red and gave the first model the name Coaster Wagon No. 1.

As **AMERICAN** *as* **APPLE PIE**

IN THE EARLY DAYS, ANTONIO WOULD eat most of his meals alone in his garage. On some days, he would buy one of the only treats he could afford— apple pie. Later in life, his favorite dessert was always apple pie (and watermelon, which he thought of as American, even though the fruit originated in Africa). He would later tell his grandchildren that his daily diet consisted of a whole apple pie and a "brick of ice cream."

A CENTURY OF SMILES
RADIO FLYER STORIES

On my first birthday, my uncle gave me a red Radio Flyer—what a great present! I had room for myself, my cousin, and my doll to ride. My older cousins got to pull us. It was lots of fun. As I grew older, I remember the wagon helping us carry a bucket of water from the spring, across the field, and to the house, or taking it on a trip to the corner store for a bag of groceries. Having a Radio Flyer was like having a good friend who grew up with me.

—VICKI P. • Fort Mill, SC

The LIBERTY Line

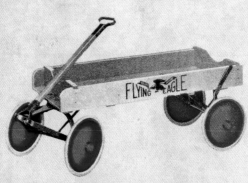

SLED RUNNER

Interchangeable for wheels on wagons or scooters. Makes the toys suitable for all year round service at small cost.

WHEEL

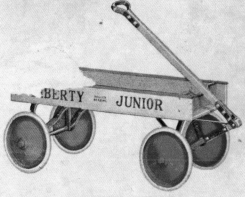

Smooth rim of three-ply steel furnishes natural cradle for high grade rubber tiring. No riveting. No spot welding.

Note hub construction and bushing thru which axle is placed.

Heavy gauge metal discs.

FLYING EAGLE

Size of Body—16"x36".
Wheels—10" Roller Bearing Steel Disc.
No. 294 Model—Red Wheels, ¾" tire—weight 34 lbs.
No. 295 Model—Yellow Wheels, 1⅝" tire—weight 36 lbs.
Body of seasoned birch—extra strong. Equipped with exclusive Liberty steel disc wheel. Sleek and trim in appearance—the wagon of every child's dreams.

LIBERTY JUNIOR

Size of Body—12"x28"—weight 20 lbs.
Wheels—8" Roller Bearing Steel Disc.
No. 291 Model—Red Wheels, ⅝" tire. Red trim on body.
Just a good, strong coaster wagon for the smaller boy or girl—body of birch well nailed together. Will stand up under rough usage.

SCOOTER

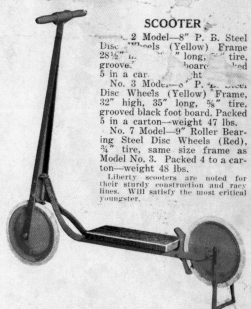

No. 2 Model—8" P. B. Steel Disc Wheels (Yellow) Frame 28½" ... " long, ... tire, groove ... board ... ed 5 in a car ... ht.

No. 3 Model—8" P. B. Steel Disc Wheels (Yellow) Frame 32" high, 35" long, ⅝" tire, grooved black foot board. Packed 5 in a carton—weight 47 lbs.

No. 7 Model—9" Roller Bearing Steel Disc Wheels (Red), ¾" tire, same size frame as Model No. 3. Packed 4 to a carton—weight 48 lbs.

Liberty scooters are noted for their sturdy construction and racy lines. Will satisfy the most critical youngster.

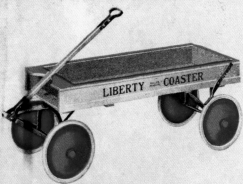

LIBERTY COASTER

Size of Body—16"x36".
Wheels—10" Roller Bearing Steel Disc.
No. 292 Model—Red Wheels, ¾" tire. Red trim on body—weight 33 lbs.
No. 293 Model—Yellow Wheels, 1⅝" tire. Green trim on body—weight 35 lbs.
Designed for utility and beauty—side pieces cut out of solid birch giving moulding effect—no pieces tacked around top edge—overlapped at ends for nailing—will not come apart.

PEDAL CAR

No. 1 Model—Stands 18" high from floor to handle. 5" wheels in back and 8" in front. Packed 6 and 12 to a carton—weight 33 lbs. and 65 lbs. respectively.

MANUFACTURED BY LIBERTY COASTER MFG. CO. 6041-51 W. Grand Avenue CHICAGO, ILLINOIS

THE FAMOUS "LINDY FLYERS"

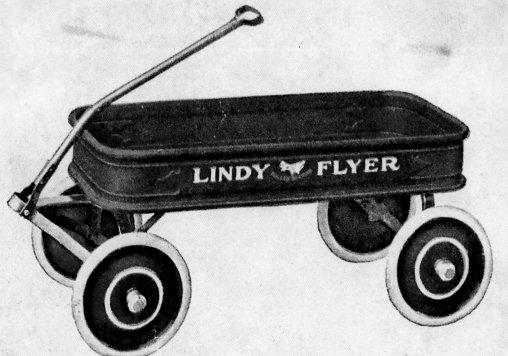

Model No. 10

" Tires

Packed 1 in
Carton
Shipping Weight
34 Lbs.

Model No. 12

1" Tires

Packed 1 in
Carton
Shipping Weight
35 Lbs.

This Is The Sturdiest Built Coaster Wagon On The Market Today
Please Note The Following Special Features

BODY—Size, 15" x 33½"; depth, 5"; twenty gauge steel throughout. Full ¾" roll top and bottom of sides. Special raised panel for name. Bottom ribbed and reinforced. Bottom and sides firmly welded together. Prevents any sag or buckle at ends. Built like a battleship.

GEAR—Bolsters formed from heavy No. 12 gauge steel and firmly attached to axle. No weight will spread channel and bind wheels. Strong braces front and back. Turntable of new design solidly riveted together, furnishing larger riding surface and no loss of parts. Entire gear attached to body with seven bolts and lock washers. Axles full half inch steel. A very compact strong running gear throughout.

WHEELS—10" Dia. new design double disc No. 20 gauge steel. Our exclusive type of hub retaining ten roller bearings. They have free movement giving easy riding and smooth running. Hub caps nickel plated and easily attached—but once put on will not come off readily. One of the best wheels used in coaster wagon construction today.

FINISH—Body enameled a beautiful lustrous RED—just the color that appeals to young and old. Will stand rough usage. Wheels also enameled red with a wide yellow stripe. Makes a wonderful combination. Gear and tubular steel handle finished in glossy black. The whole job looks like a million dollars. Will sell on sight.

RADIO STEEL & MFG. CO.

WHY "RADIO FLYER"?

ANTONIO PASIN WAS ALWAYS FASCI-
nated with modern invention and design, and this
fascination inspired him to use the most modern
materials, like steel, in his inventions, and to never stop tinkering
to improve his designs (he developed over a dozen models of the
wagon in its first ten years of production). He believed in quality,
and set out to create pieces that were built to last into the future—
something to be enjoyed by chil-
dren and, one day, their children.

Three years after transition-
ing to all-steel wagons, he came
out with a new model and named

Above: An illustration of the original all-steel Radio Flyer wagon, painted
in Radio Flyer's signature red. Antonio was deeply inspired by modern
innovations and chose to reflect that in his wagon names, designs, and
materials. *Opposite:* An advertisement for the Lindy Flyer, named for Charles
Lindbergh's record-breaking transatlantic flight from New York to Paris in 1927.

it Radio Flyer after two of the greatest innovations of the time—the
radio and airplanes. More specifically, Antonio was inspired by the
Italian inventor and engineer Guglielmo Marconi, who developed
the long-distance telegraph and broadcast the first transatlantic
radio signal, and Charles Lindbergh, who accomplished the first
solo nonstop transatlantic flight from New York to Paris. After
Lindbergh completed his record-breaking flight in 1927, Antonio
created the Lindy Flyer wagon,
first in wood and then in steel,
which became the company's
top-selling wagon alongside the
Radio Flyer.

RADIO FLYER RED

ANTONIO FASHIONED THE VERY FIRST RADIO FLYER IN 1930 IN RED because it was his favorite color. This might not come as a surprise, as Italians love the color red—think Ferraris, pizza, and wine. It was also likely that he chose this color because Antonio believed it was patriotic, and it also may have had something to do with his experience as a young boy working as an apprentice to the master Veronese painter at the Villa Giusti estate in Italy. One of the most important skills Antonio learned during his time there was how to mix paints into any color you could imagine. One of the most difficult colors to create successfully was a rich cherry red—the same color the Radio Flyer wagon is today.

There was a time—for the first few decades of the company's existence—that Antonio's wagons came in various shades of blue, green, yellow, and other colors. But red always sold the best. Maybe that's because it's a color that conveys excitement and speed, and it also represents love. In time, red prevailed as the most popular, and the little red wagon became the iconic representation of American childhood.

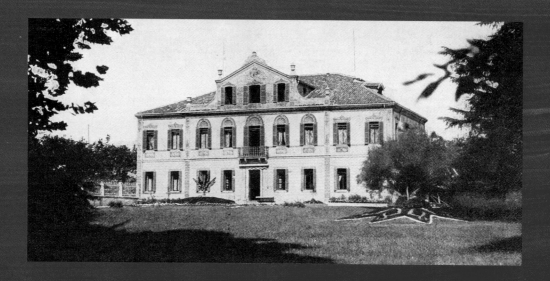

Above: The Villa Giusti is in northern Italy close to where Antonio grew up. It served as the site of the signing of the Armistice of Villa Giusti on November 3, 1918, which ended the First World War between Austria-Hungary and Italy on the Italian front.

A CENTURY OF SMILES

RADIO FLYER STORIES

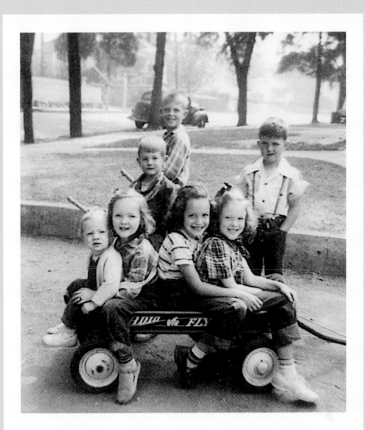

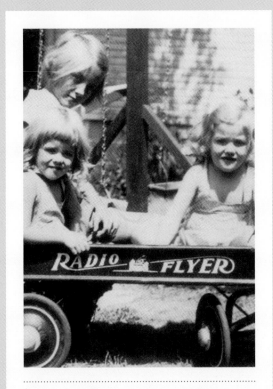

— LINDA M. • Springfield, OH

In the Highland Park area of Los Angeles in the 1940s, extended families crowded into gracious old homes to save money and space during the war. Playmates abounded, and we all had clip-on skates—but my family owned a bright red Radio Flyer! The only family with more prestige among the kids was the one with the TV. That Flyer got a good workout every day, coasting with a load of kids down the Meridian Street hill to steep Avenue 57 at breakneck speed, just making the left-turn corner and nearly flying for real halfway down on our "bailout" lawn.

— KAREN F. • Santa Cruz, CA

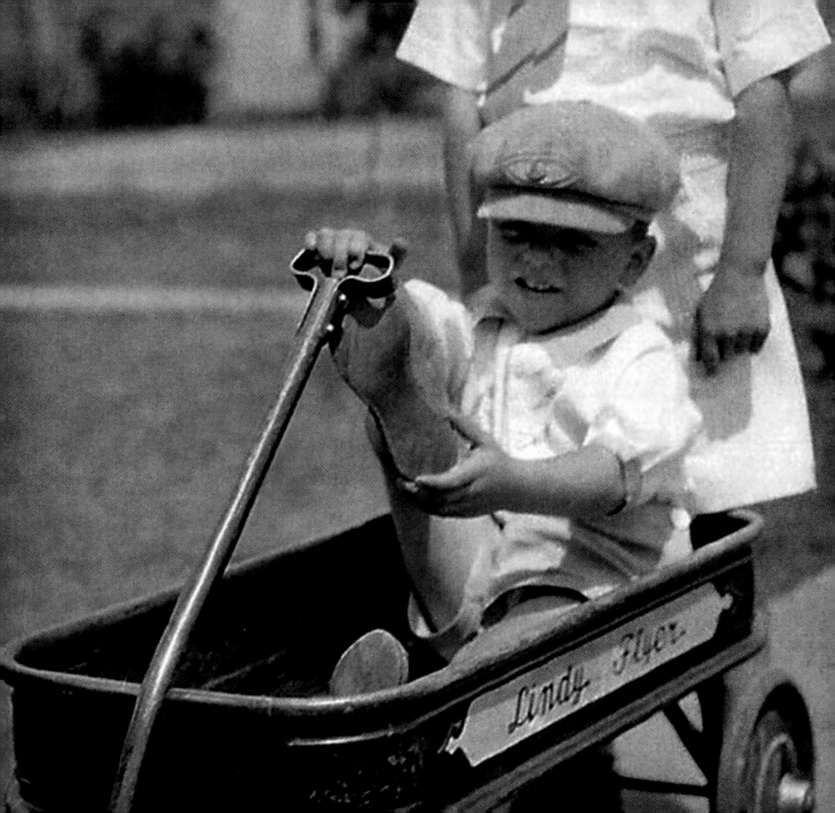

RADIO FLYER

in the

DEPRESSION

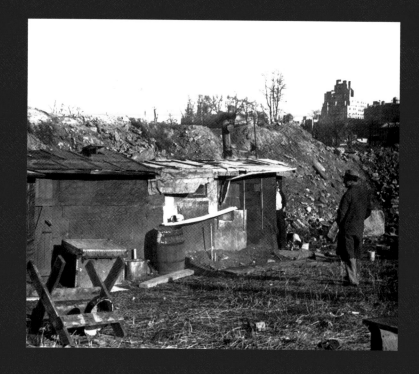

THE GREAT DEPRESSION IS

considered one of the defining periods of American history. During this time, the American economy came reeling out of the furious pace of industrial innovation and buzzing consumption of the 1920s, and then jolted to a screeching halt with the stock market crash in October 1929.

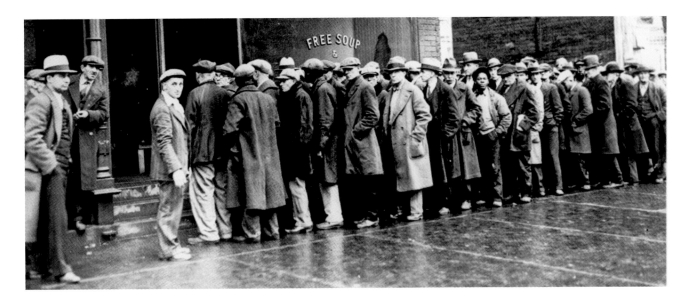

ITHIN A YEAR OF THE MARKET collapse, four million families were left without savings or support. Unemployment reached 24 percent by 1932. For the first time in America's history, more people were leaving the country than entering it. Men selling apples for a nickel apiece began appearing on street corners outside of empty department stores. Families across the country were forced to pack all of their belongings into the family car and leave their homes. Many of them settled into makeshift "Hooverville" shantytowns.

Life was hard for kids during the Depression. Children's rocking horses, train sets, Erector Sets, and other popular toys were among the first items to be left behind or sold to buy food and other necessary living supplies. Kids had to learn to do without, just as their parents did. Many could not attend school because they had to work. The power of children's imaginations became their most important link to a world where childhood was still a time of innocence and play. Kids resorted to creating their playthings out of recycled tin cans, egg crates, odd pieces of wood, rope and twine, and whatever other materials the diligent seeker could find. In this environment, it's not surprising few toy companies survived.

But Radio Flyer was an exception. In fact, Radio Flyer's production levels of coaster wagons remained at a steady incline throughout the Depression, and by the end of it, sales were soaring—Radio Flyer was among the most trusted children's products in the nation.

Above: Men line up outside a building for free soup. Soup kitchens were commonplace following the onset of the Depression. *Opposite:* A Hooverville, or shantytown, in the 1930s. Hoovervilles were named after President Herbert Hoover, who was president at the start of the Great Depression and widely blamed for it.

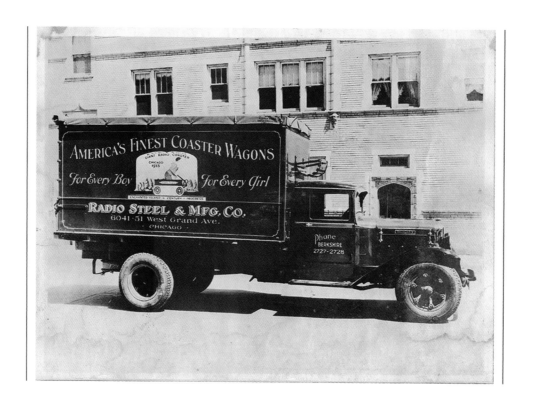

FOR EVERY BOY. FOR EVERY GIRL.

WHEN ANTONIO PASIN CREATED the Liberty Coaster Company, he chose "For every boy. For every girl" as its slogan. He considered it more than just a nice and inclusive phrase—he took that promise seriously. Pasin dedicated himself to the task of one day supplying every American family with a wagon, and to the equally difficult task of constructing a product that would become an heirloom—one that would survive entire childhoods to be passed down to the next generation.

This meant producing a wagon that was not only affordable for all families, but also durable. Antonio had learned his trade making handcrafted and reliable furniture for his neighbors,

who, like him, were people of modest means. From the very beginning of starting his own business, even before making his first wagon, his goal was to match low cost with high quality. Therefore, when hard times hit in 1929, he was ready.

When the Great Depression began, factories started to close their doors or slow their production lines to a near standstill, which Antonio used to his advantage—he found this gave him the first choice of the best-quality materials for half the price. As other toy, automobile, and appliance factories went out of business across Chicago, Pasin would buy their scraps for cents on the dollar. After switching from an all-wood to an all-steel design for the coaster wagons in 1926, Antonio quickly reacted to the opportunity he saw in the new abundance of scrap metals and other materials. He took out a line of credit and invested every penny of the company's savings to buy the automobile factory next door. He changed the title of the company from Liberty Coaster Company to Radio Steel & Manufacturing Company in 1930.

While most other surviving companies tried to diversify their product lines to offer cheaper (and less well-made) options, Antonio focused on creating just one

product: his high-quality Radio Flyer wagon. More than cutting down on costs, this decision allowed the company to sell the wagon at a lower price than anyone else. Other toy companies, including Garton Toy Company in Wisconsin and the Gendron Iron Wheel Company out of Ohio, were selling toy coaster wagons across the country as well, but never adopted these same mass-production techniques. These larger companies' focus was also on a much wider range of toys and kids' products with wheels, creating an opportunity for Radio Steel to capture the market with its reliable and reasonably priced red wagons.

Radio Steel stayed the course and continued to increase its production and sales without buying a single traditional advertisement or resorting to the cheaper plastic and scrap substitutes that were just starting to be imported from Japan. Antonio understood that his customers feared the continual fluctuations in prices that dominated the industry, which forced them to limit their purchases. But by offering the Radio Flyer at a fixed price for many consecutive years (without compromising on quality), the company earned the public's trust and showed it knew how to keep its promises.

Above: The letterhead used by the Radio Steel & Manufacturing Company. In 1930, Antonio changed the name of the company and style of design to reflect the times. *Opposite:* The original delivery truck of the Radio Steel & Manufacturing Company featuring the company's slogan, "For every boy. For every girl."

AMERICA'S FINEST

For Every Boy

WE INVITE YOU
GIANT RA

CHICAGO
1933

ENCHANTED ISLAND

RADIO STEE

6041-51 Wes

· CHI

COASTER WAGONS

TO VISIT OUR
COASTER

LYER

ENTURY of PROGRESS

For Every Girl

& MFG. CO.

Grand Ave.

AGO

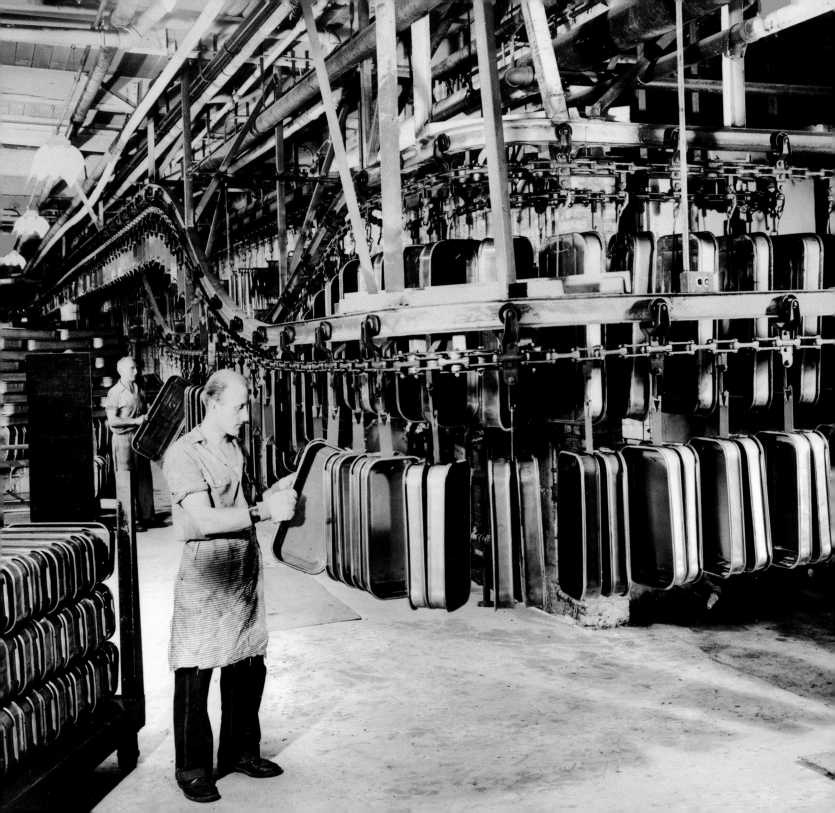

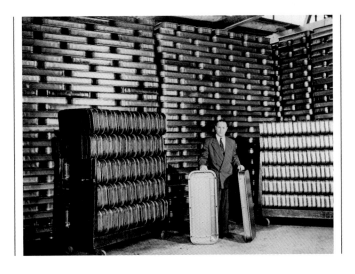

THE TOY INDUSTRY'S "LITTLE FORD"

ANTONIO PASIN WAS ALWAYS INTER-ested in the most modern ways of doing things, whether by using new materials, adopting the best practices for production used by factories in different industries, or constantly rethinking his designs to make them more durable, simpler, or sleeker. Rather than listen to his wood wagon competitors who accused his steel wagon of being dangerous—too hot in the summer and too cold in the winter—he continued to tinker and modernize every aspect of the wagon's design.

One of the most important strategic decisions he would ever make was to adopt the same mass-production techniques used by the automobile industry, pioneered by Henry Ford while manufacturing the Ford Model T. Antonio invested in the same machines the automobile industry used to stamp metal, and reorganized his workers into assembly lines accompanied by the machines that were thoughtfully arranged to do the heavy lifting. It was revolutionary for a toy company to operate at this scale, and the results speak for themselves: Between 1931 and 1938, production *doubled* from 3,000 to 6,000 pieces a day, which amounted to no fewer than 1,500 shiny new wagons daily.

Above: Antonio's methods for mass production of wagons were modeled after the automobile industry's. *Opposite:* Two workers load stamped-steel wagon bodies onto a conveyor belt.

By the end of the decade, Radio Steel & Manufacturing Company was the world's largest manufacturer of coaster wagons, and Antonio Pasin had come to be known as the "Little Ford" of the toy industry. So productive were Radio Steel's manufacturing techniques that an economist from the University of Chicago came down to study Radio Flyer's production, convinced that the company could not still be profitable while selling the wagons at such an affordable price.

Most important, Antonio had kept his promise. Using discounted materials and efficient production techniques not only saved the company, but allowed it to maintain its prices without compromising on quality—no matter how bad the economy got. It is because of this trust that Radio Flyer really became an icon of American culture. Besides surviving as a company and offering a standard line of products that epitomized quality and reliability, the Radio Flyer identity had been cemented by the trials of one of the toughest decades in America's history. The little red wagon became symbolic of the same resilience and can-do spirit that defined a generation of children and families—it not only represented a child's play and soaring imagination, but also encouraged hope for the future. And many of those children, who turned into parents and grandparents, would pass down their little red wagons in remembrance of simpler times.

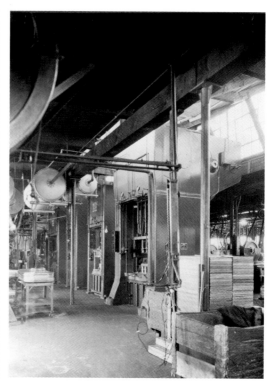

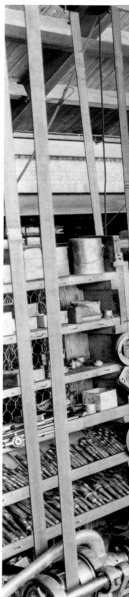

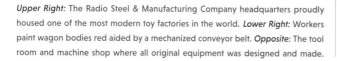

Upper Right: The Radio Steel & Manufacturing Company headquarters proudly housed one of the most modern toy factories in the world. *Lower Right:* Workers paint wagon bodies red aided by a mechanized conveyor belt. *Opposite:* The tool room and machine shop where all original equipment was designed and made.

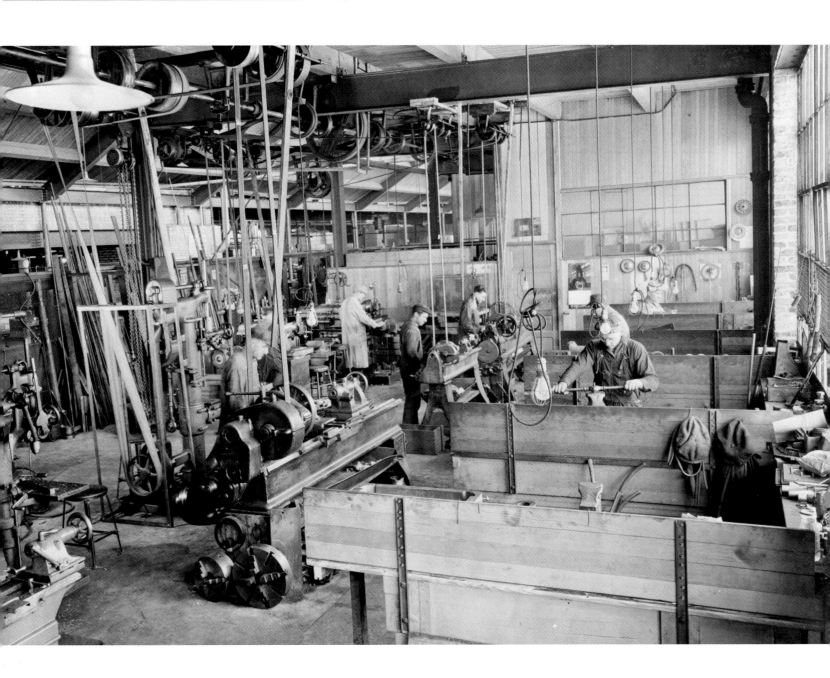

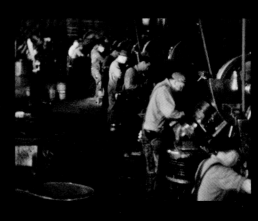
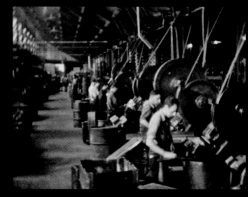

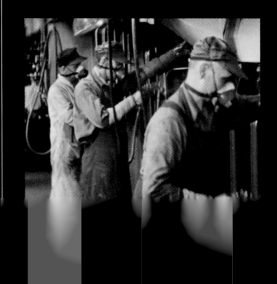
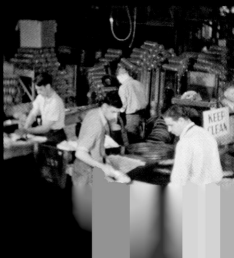

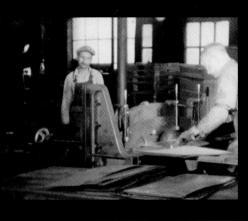

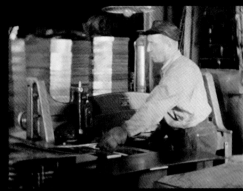

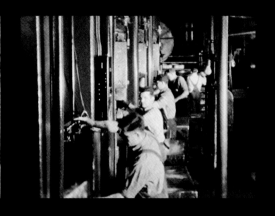

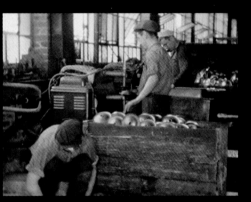

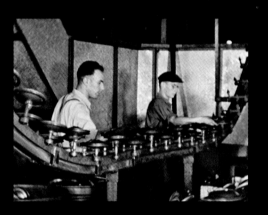

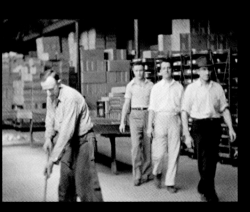

Stills from Antonio's home movies featuring workers in a variety of daily jobs: welding, assembling, and inspecting the various parts of the wagon, painting the steel bodies, and sweeping and maintaining the factory. He used a 16mm camera to capture what was happening at the factory and brought the films back to Italy to show his family what he was doing in America.

WORKING AT RADIO FLYER

WHEN ANTONIO PASIN STARTED his business, the company consisted of little more than himself, an empty garage, and his first wooden wagon full of carpentry tools. By the close of the 1930s, Radio Steel was the world's largest and most productive manufacturer of coaster wagons, employing more than 140 full-time workers in a factory that Antonio described as "roomy enough to fit 125 cars!"

Not only was the factory large, but it also housed some of the best working conditions, and pay, for manufacturing labor at the time. Just as he had not raised prices for consumers during the economic downturn, Antonio vowed to maintain high salaries for his employees, with an astounding *zero* pay cuts during the Depression. In a period when national unemployment was as high as 25 percent, and in certain neighborhoods in Chicago up to 40 percent, this was almost unheard-of.

Of the 140 workers at Radio Flyer, a large portion were fellow Italian immigrants and former neighbors. Remembering his difficult first days in America, Antonio

Above: Employees walking into the Radio Steel & Maufacturing Company factory from the outside grounds.

tried to ease the way for his employees by bringing in an English teacher to provide language lessons, offering interest-free loans, and supplying the Radio Flyer Employee Insurance Plan, which included best-in-class protection for all of Radio Flyer's workers. The company even had its own bowling league and provided a subsidized cafeteria with an Italian cook. Antonio considered the company's consistency and reliability with its workers to be two of its greatest accomplishments.

These practices were a part of what Antonio called "a very simple system" whereby having a singular focus on one product allowed the company to pass on the savings to its consumers and continue to pay its workers a healthy wage. This process demonstrated to its competitors that "these two paradoxical terms are perfectly compatible." In one particularly bad month early in the Depression, Antonio simultaneously lowered the products' prices and raised salaries. "The psychological results," he later wrote, "were a prodigious increase in production." If Radio Steel had not already made its loyalty to its customers and employees absolutely clear, moves like this certainly did.

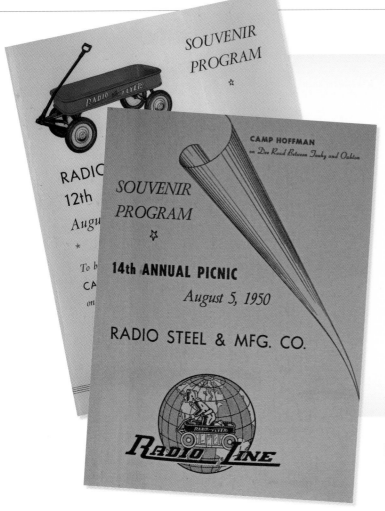

SOUVENIR PROGRAM

☆

RADIO

12th

Augu...

★

To b...

CA...

on...

CAMP HOFFMAN
on Dee Road Between Touhy and Oakton

SOUVENIR
PROGRAM
✡

14th ANNUAL PICNIC

August 5, 1950

RADIO STEEL & MFG. CO.

Radio Line

Activities

MUSIC, DANCING, BOAT RIDES, PONY RIDES
RACES, GAMES, CONTESTS

★　　★　　★　　★　　★

BOCCE, BASEBALLS, HORSESHOES
AND PINOCHLE CARDS
will be available for all who care to play

Program of Events

1:30　CHILDREN'S RACES
2:00　LADIES' CONTESTS
2:30　EGG THROWING CONTESTS
3:00　MEN'S SINGING CONTEST
5:30　DRAWING FOR CHILDREN'S PRIZES

Above: The programs for Radio Steel's twelfth and fourteenth annual company-wide summer picnics. As one of the many customs of working at Radio Steel, employees often socialized and raised their families together—several children of Radio Steel employees even chose to work alongside their parents once they had grown. *Right:* Two secretaries pose for a picture at their desks.

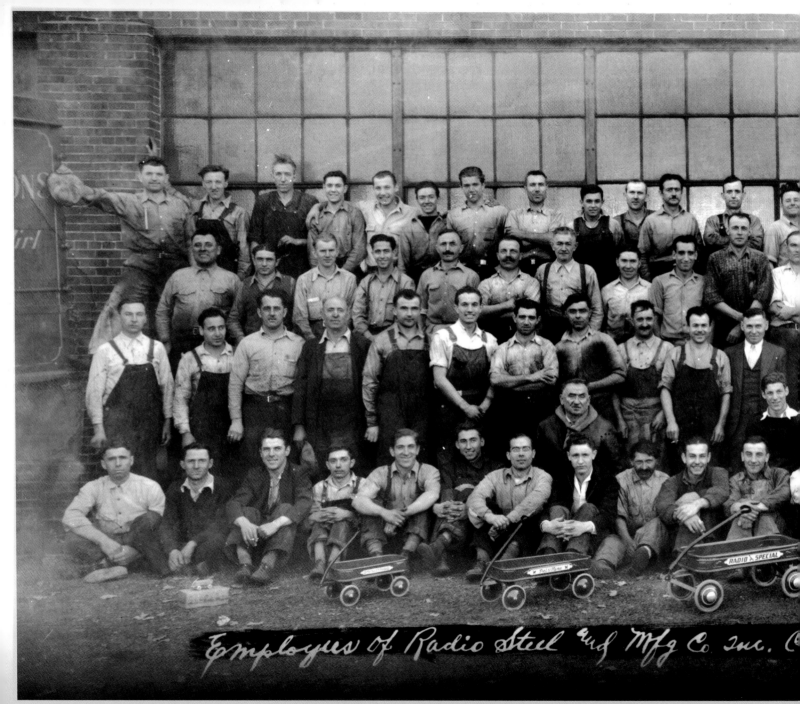

Employees of Radio Steel and Mfg. Co. Inc.

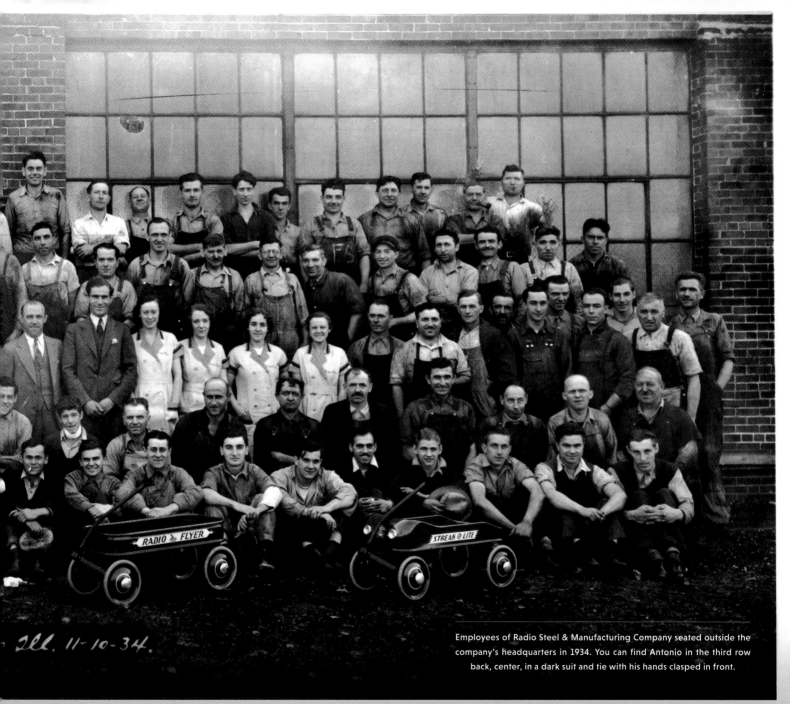

Ill. 11-10-34.

Employees of Radio Steel & Manufacturing Company seated outside the company's headquarters in 1934. You can find Antonio in the third row back, center, in a dark suit and tie with his hands clasped in front.

<div style="text-align: center">

OTHER POPULAR TOYS
of the 1930s

</div>

DURING THE DEPRESSION, PEOPLE EXPERIENCED THE UNUSUAL situation of having ample time and little to no money to spend. Adults listened to the radio, read the daily newspapers, and played a lot more games, like solitaire. Unusual hobbies and competitions—such as pie-eating contests, stamp collecting, tree sitting, mini golf, and marathon dancing—became the norm as hobby clubs of every variety and local YMCAs became the center of communities looking to pass the time. Jigsaw puzzles reached an all-time high in popularity, and board games like Sorry! and Scrabble came onto the scene. Monopoly (which major toy manufacturer Parker Brothers predicted would flop because it was "too dull, too complex, and took way too long to play") became an overnight sensation in 1935, and is now the most popular board game in history.

Children mostly played with their older siblings' hand-me-downs, and any new toys that came out were simple and required imagination. The yo-yo, jacks, pick-up sticks, and Slinky all became popular. (Fun fact: The Slinky was invented by accident when its creator, Richard James, a mechanical engineer, knocked over a long spring he had made and watched it "walk" down from its place instead of falling.) Kids played with dolls like the Rockford Sock Monkey or passed back and forth beach balls made from a newly popular material called "plastic."

Above: Three popular games and pastimes in the 1930s were puzzles, Scrabble, and jacks.

It was 1936 in the Bronx. I was four years old, and the doctors had diagnosed me with rheumatic fever. The treatment was for me to lie in bed until my condition improved. My only contact with the world outside my bedroom was each afternoon when my father came home from work. He lined the bed of my Radio Flyer with a blanket and a pillow and took me for a forty-five-minute journey around the neighborhood. I sat quietly in the Radio Flyer while Dad dutifully pulled me around. Dad waved at neighbors, introducing me to everyone he knew and even those he did not. Every day I waited for my dad to get off work and come home to lift me into the Flyer and pull me around the streets. For four years all I knew of the outside world I discovered from my position inside my Radio Flyer. Dad is gone, as is my wagon, but my memories of both fill my heart.

— RON C. • Honolulu, HI

A CENTURY
OF SMILES
RADIO FLYER STORIES

When my brother was four, he was told that my parents were getting him a little sister. When I was adopted, he took hold of my hand and I was indeed his. Since I was only eighteen months old, I couldn't ride on his tricycle. So he hooked up the red wagon and rode me up and down the street, and sometimes would pull me up a small hill where together we could ride down. His continued imagination with that wagon gave me many happy and loving memories of my childhood.

— MARTHA D. • Birmingham, AL

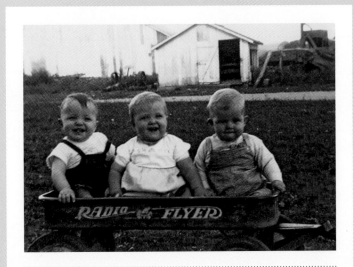

— CAROL K. • Marshall, MO

Every kid should have a Radio Flyer.

— DANA N.

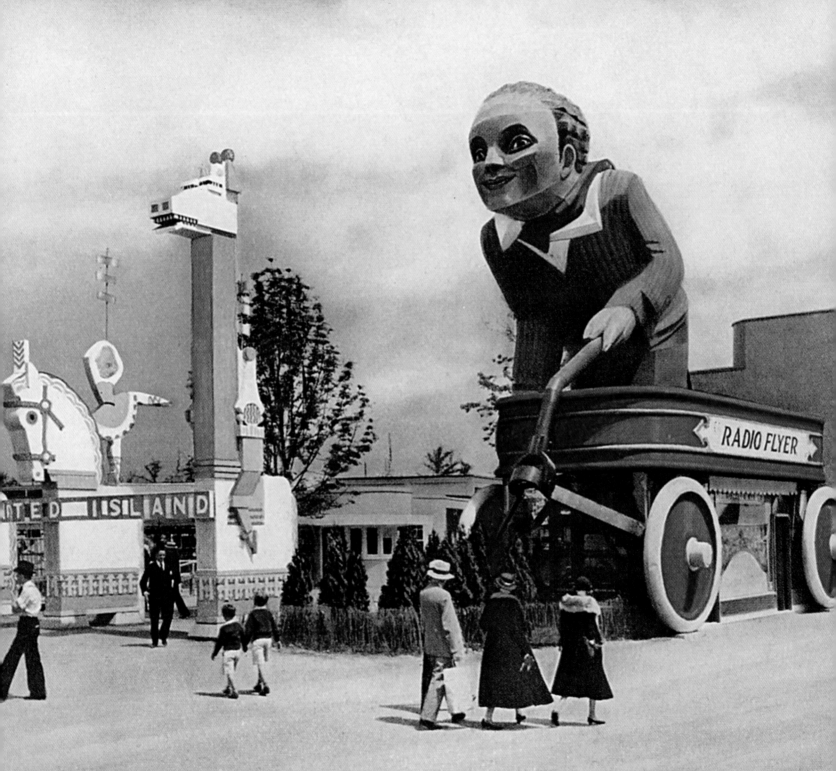

The WORLD IS YOUR SHOWCASE

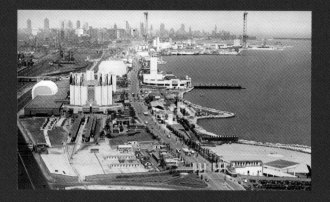

ON MAY 27, 1933, THE CITY OF CHICAGO,
still in the middle of the Depression, opened the gates
of the Century of Progress Exposition to a crowd of the
waiting public. Six years earlier, several of Chicago's
political and business leaders had come together to make
plans for a world's fair exposition that would showcase
Chicago's industrial progress and celebrate the city's
hundredth anniversary. They selected oil tycoon Rufus
Dawes to serve as chairman of the fair's board, and his
brother Charles Dawes, a former U.S. vice president, to
serve as head of the finance committee.

"I welcome the celebration you are now beginning. It is timely not only because it marks a century of accomplishment, but it comes at a time when the world needs nothing so much as a better mutual understanding of the peoples of the earth."

— PRESIDENT FRANKLIN D. ROOSEVELT

FROM THE BEGINNING, THE COMMISsion members shared a belief that the buildings should not reinterpret past architectural forms—as had been done at earlier fairs like Chicago's 1893 World's Columbian Exposition—but should instead reflect new, modern ideas, as well as suggest future architectural developments. Originally intended to commemorate Chicago's past, the Century of Progress Exposition came to symbolize hope for Chicago's, and America's, future. With the slogan "Science finds, industry applies, man adapts," the fair stressed the correlation between industry and science and the juxtaposition of traditional and futuristic forms.

When the 1929 stock market crash happened, many of the investors in and political supporters of the fair backed out—but not the Dawes brothers. They believed the fair was vital to bringing pride back to the ailing city and revitalizing its business district. They decided to double down on their personal stakes in the fair, and convinced a large coalition of smaller local business figures to secure the $12 million in gold notes required to underwrite the initial construction of the fair.

The investment was a huge risk—a world's fair had never been profitable before, and there was no reason to believe this one would be any different. But desperate times called for extraordinary measures and, following the Daweses' lead, Chicago went all in, too—the city designated three and a half miles of newly reclaimed land along the shore of Lake Michigan for the fair, commissioned architects from around the world to design more than eighty buildings, and invited hundreds of America's companies to build more than eighty-four miles of free exhibits to showcase their histories and advertise their newest products.

One of the businesses registered for a permit at the fair was Radio Steel & Manufacturing. Antonio Pasin had heard of the fair a year before its opening, and he seized the opportunity to be a part of it. Not many toy companies would participate in the fair, which was dominated by transportation and science exhibits. But Antonio knew this was an opportunity he could not miss, and he believed his well-made wagons should stand proudly next to the latest and greatest transportation innovations.

Opposite: An aerial image of the 1933 World's Fair grounds in Chicago.

—THOMAS I. • Chicago, IL

— THOMAS A. • Manchester, CT

A CENTURY OF SMILES

RADIO FLYER STORIES

We grew up in the small town of Flagstaff, Arizona. The Radio Flyer wagon was as much a novelty as my sister Laura and I were, as one of the few sets of twins in town.

— LAURA C.
• Denver, CO

To a child of the 1940s, a special toy and sharp imagination brought untold adventures. I should know: I was that child. My special toy was given to me on my third Christmas—a shiny red Radio Flyer with black rubber tires, metal hubcaps, and a bed deep enough to carry serious material and an even more serious little girl. That wagon became my vehicle to Mars, my horse that led to the desolation of cattle-rustling thieves, even the fire truck that saved our neighborhood. I'd sit with my right leg bent under, nestled in the wagon, my left leg dangling over the side, foot pushing hard against the pavement, propelling me forward. My Radio Flyer lasted into the 1970s, when my three-year-old was given the privilege of riding in that old chariot attached behind her grandfather's lawn mower. Watching from the front porch of our homestead, I finally realized what my wise parents had always known: The joys and freedoms of childhood are intrinsically connected to the ownership of a Radio Flyer.

— THOMAS A. • Manchester, CT

EXPLORING
the ENCHANTED ISLAND

ARRIVING ON THE ENCHANTED ISLAND AT THE HEART OF THE WORLD'S Fair was like stepping into a child's imagination. The five-acre strip of land was filled with marvels and amusements for children and described by the *Chicago Sunday Tribune* as "truly a dreamland come to life." Soaring above the lagoons, children would first enter the fairground with their families by gliding 210 feet overhead along the aerial cable track of the Sky Ride, whose steel web of towers, 628 feet high, made it the highest man-made structure west of the Atlantic Coast. A family might first visit the Hall of Science or see the gigantic globe highlighting the Ford Motor Company's operations around the world, before wandering through the many colored buildings of Rainbow City along the fair's waterfront and stopping for a bite to eat at the Belgian Village or Streets of Paris. Then the children would make their way on a ferry to the Enchanted Island.

The first sight children saw after landing on the island and passing beneath the Enchanted Island archway was the colossal Coaster Boy exhibit created by Radio Steel & Manufacturing Company. Antonio Pasin had gone to great pains to secure the spot front and center for the exhibit, which tens of thousands, and eventually millions, of children would see, tugging their parents by the arm to get a closer look.

Then, after watching the workers fashion the little red wagon souvenir pieces and perhaps buying one for themselves, children could walk through a house built entirely out of millions of colored marbles and then hop on a train built to tour them through a wonderland of large storybook characters—Jack and Jill, Pinocchio, Little Red Riding Hood, Alice in Wonderland, and an old woman putting her children to bed in a shoe.

When they had had their fill of merry-go-round and Ferris wheel rides, they might climb to the summit of the Magic Mountain and then glide down a slide hidden behind a small castle back to the ground below. Children who wanted to rest their legs could then go to the children's theater to watch one of the afternoon puppet shows before joining their parents to leave the island—still holding one of their miniature little red wagons as a souvenir for the day.

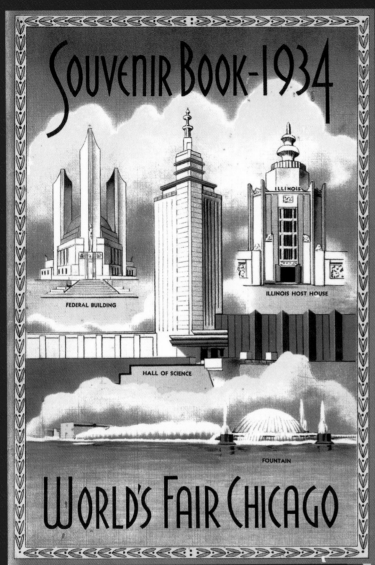

SOUVENIR BOOK-1934

FEDERAL BUILDING

ILLINOIS HOST HOUSE

HALL OF SCIENCE

FOUNTAIN

WORLD'S FAIR CHICAGO

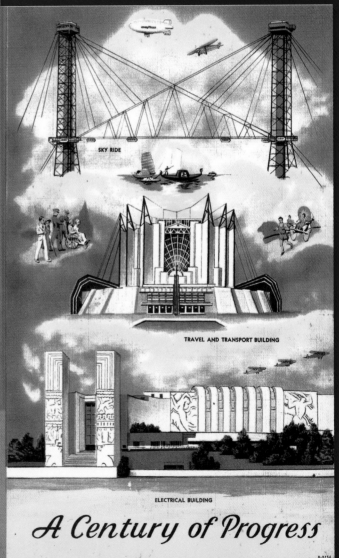

SKY RIDE

TRAVEL AND TRANSPORT BUILDING

ELECTRICAL BUILDING

A Century of Progress

Above and Right: World's Fair Chicago Souvenir Book 1934. One of the most distinctive aspects of the World's Fair was its architecture and one-of-a-kind buildings and structures displaying the feats of the Century of Progress. The modern marvels pictured above: Federal Building, Illinois Host House, Hall of Science, Sky Ride, Travel and Transport Building, and Electrical Building, entering into the fair.

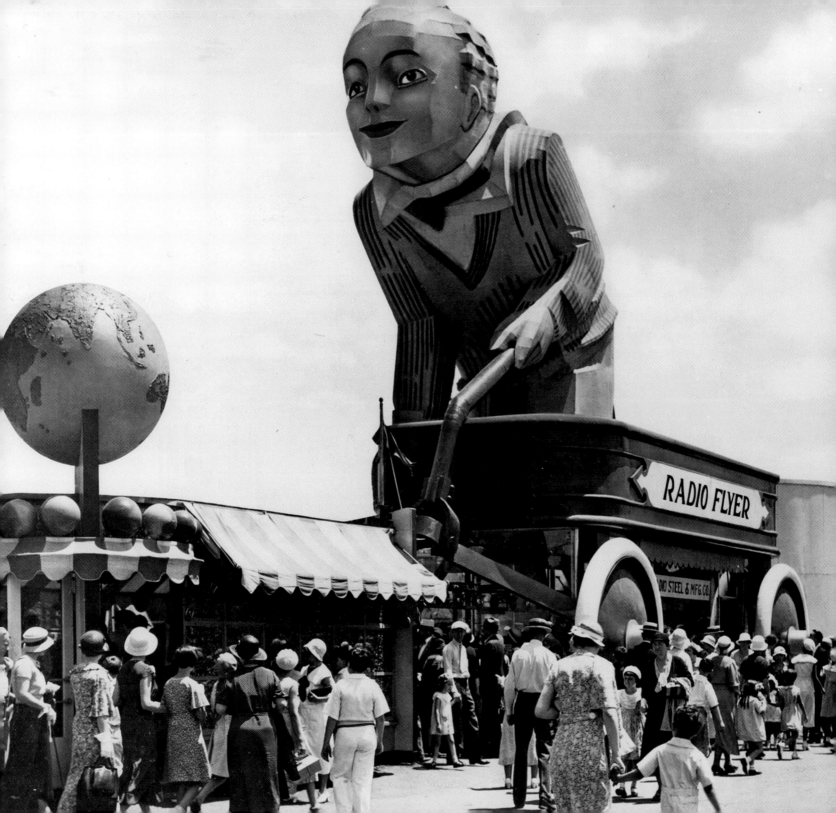

ANTONIO'S NOT-SO-LITTLE WAGON

LIKE THE ORGANIZERS OF THE FAIR, Antonio went all in when planning the Radio Flyer exhibit. He took out a thirty-thousand-dollar loan (equivalent to half a million dollars today), backed by the factory and the company's steady sales. It was the biggest risk he had taken since starting the business. He had a factory, he had customers, and he was starting to build a brand, but it was the middle of the Depression—there was no denying that things were still unstable. It was the first time Antonio had ever taken on debt, and his wife, Anna, later remembered that year as the only time she ever saw him have trouble sleeping, as he lay awake asking himself if such a bold move had been the right thing to do.

When Antonio shared his plans for the exhibit, he was accused by many of his longtime workers of "attempting the unreasonable." First he had to apply for and get a permit to build a building inside the exposition. After acquiring a permit, he needed to create an exhibit that would make a big impact and attract fairgoers. He decided that not only did he want to build a colossal Radio Flyer wagon that was to scale, but he wanted that wagon to be large enough to house a shop beneath it for workers to make and sell miniature wagons as souvenirs to customers—and he wanted to contract one of the city's most renowned art deco architects, Alfonso Iannelli, to design it.

Considered to be one of the founders of industrial design, Iannelli was famous for having collaborated with Frank Lloyd Wright on the design of the decorative sculptures in Chicago's Midway Gardens. For the Century of Progress fair, he had already been asked to design the Havoline Thermometer building—a two-hundred-foot towering thermometer with three sides that actually told the temperature in Chicago—and would later design a modern vacuum coffee maker and electric toaster for the Sunbeam Products exhibit.

It might have seemed unrealistic for a small company like Radio Flyer to attract the attention of a renowned designer, but Iannelli, a fellow Italian and dreamer, was charmed by Antonio's earnest persistence and big vision. He said yes to the Radio Flyer commission and set to work on the sculpture, following Antonio's modern plan.

Others might have thought it impossible, but within a few months, Antonio had in his hands the designs for a display of impressive proportions: 10 feet wide, 49½ feet long, and 49 1½ feet tall. It would consist of a large Radio Flyer wagon, and kneeling in the wagon would be a giant, fifty-foot boy, with one hand on the handle and the other on the side, braced for adventure. Underneath the wagon, between the ten-foot-diameter wheels, would be a glass shop where specialized workmen would construct little Radio Flyer wagon souvenirs, as if they were in Santa's workshop.

Opposite: A crowd forms around the Radio Flyer exhibit at the entrance of the Enchanted Island at Chicago's World's Fair. Roughly forty million visitors passed through in the year and a half that the fair was open.

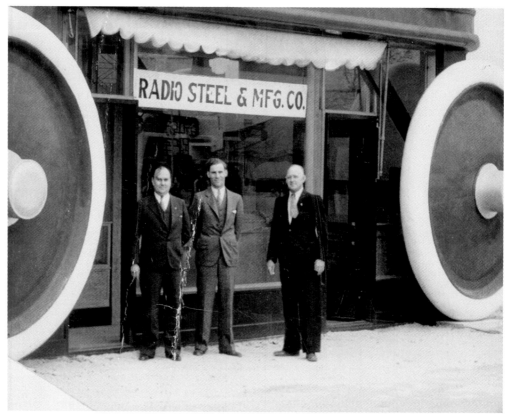

Above: Antonio (middle) in front of the completed exhibit.
Right and Opposite: In-progress shots of the construction of the exhibit, which included a fully functional workshop with glass display windows housed beneath the Coaster Boy sculpture.

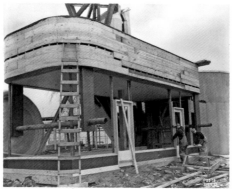

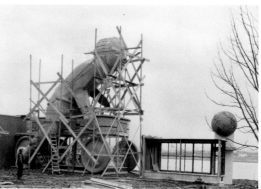

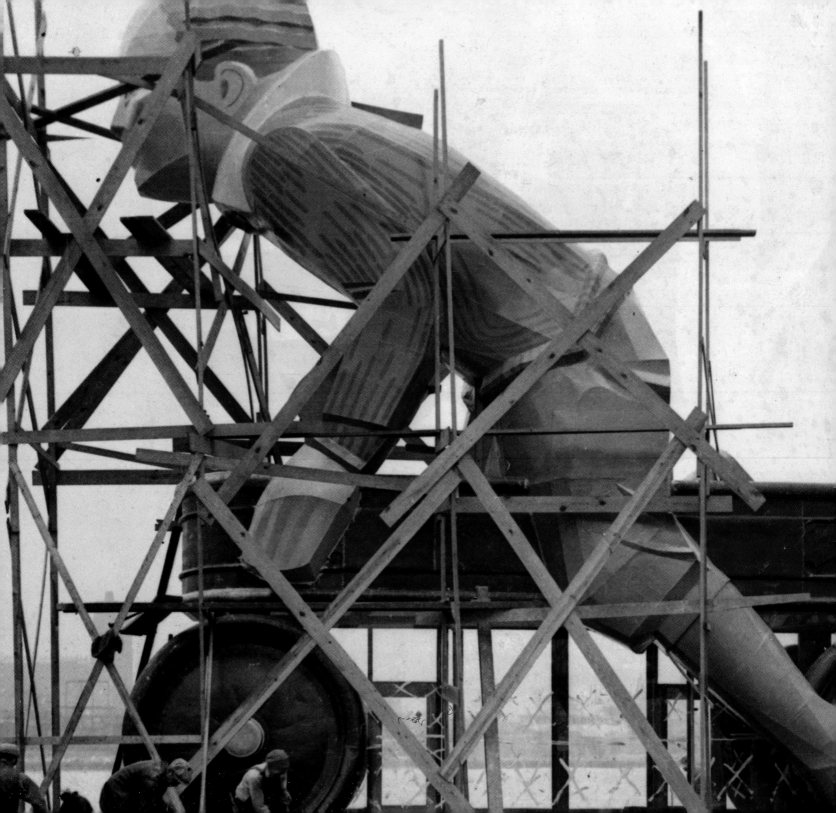

"The miniature Radio Flyers had roused the public's curiosity and they were continually sent to every part of the world upon simple requests, creating that excitement that almost made you feel the need to have a regular one."

—ANTONIO PASIN

Trained as a sculptor, Iannelli is said to have treated every project as though it were a single cubist sculpture. The results showed in the final exhibit's detailed and multifaceted features. After several months of building, the exhibit became a towering reality. The modernist design gained acclaim. The fifty-foot-tall coaster boy fashioned in a modern cubist style became known not only as "Tony" but also as the "Cubist Boy," a marvel in its own right. The gigantic structure was clearly visible among the attractions of the Enchanted Island and became the symbol of Radio Steel & Manufacturing Company. It was exactly as Antonio had envisioned.

Ultimately, the risk—both to the investors in the fair and to

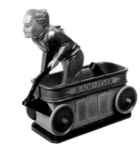

Antonio—paid off. By the end of the fair in October 1934, it had attracted more than forty-eight million visitors from around the world, becoming the first world's fair in history to make a profit. The Radio Flyer exhibit became one of the most popular at the fair. The miniature coaster wagons Antonio sold as souvenirs for 25 cents (about $4.50 today) became a staple keepsake for fair visitors. Before the end of the first year, he had sold more than 120,000 of the miniature wagons—more than enough to cover all of his debts. This was the first significant marketing effort Radio Flyer had ever made, and by the end of the World's Fair, Radio Flyer (and Chicago) had made a name for itself on the world stage.

Top: Two of the 120,000 miniature wagons Antonio sold for 25 cents apiece to visitors at the fair. *Above:* A ceramic replica of the Radio Steel exhibit at the Century of Progress World's Fair.

I was moved to tears when I received my little red wagon from a dear friend for a recent Christmas. I am eighty-five and I have wanted one since I was six. My friend told me I was never too old for a happy childhood. I am so thrilled to have the same wagon that many of my friends had when I was growing up, and that my single mother was never able to afford. This past year, I became a great-grandfather to twin girls. I know they will love this wagon, too, and that pulling my girls around will be great for exercise. This is the best Christmas present ever!

— GORDON C.

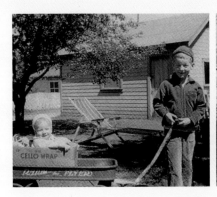

"Radio Flyer." These were magic words to the smiling six-year-old showing off his new baby brother in August 1942, in a cherished coaster wagon. With the war safely behind us in June 1948, the Radio Flyer became a part of our imaginary journey to the Old West of Gene Autry and Roy Rogers as a cozy covered wagon in my twelve-year-old mind. Now that I'm a sixty-year-old grandfather, these "little red wagon memories" came rolling back as I purchased shiny new Town & Country wagons for my granddaughter and grandson. I can only hope their Radio Flyers will be so filled with pleasant memories (but that part is "assembly required," after all)!

— ROBERT S. • Iowa City, IA

In 1929 my pa gave me a Radio Flyer wagon! It was my most prized possession. I could ride it as fast as the wind. I used the wagon to carry groceries, baked goods, lumber, and firewood for the kitchen stove. One day, while going for firewood, I was struck by a train. The wagon and my left arm and shoulder were horribly demolished. I always missed that Radio Flyer coaster wagon. But in 1995, when I was seventy-five years old, my dream came true: My wife presented me with the most beautiful replacement!

ANDREW R. • Chicago, IL

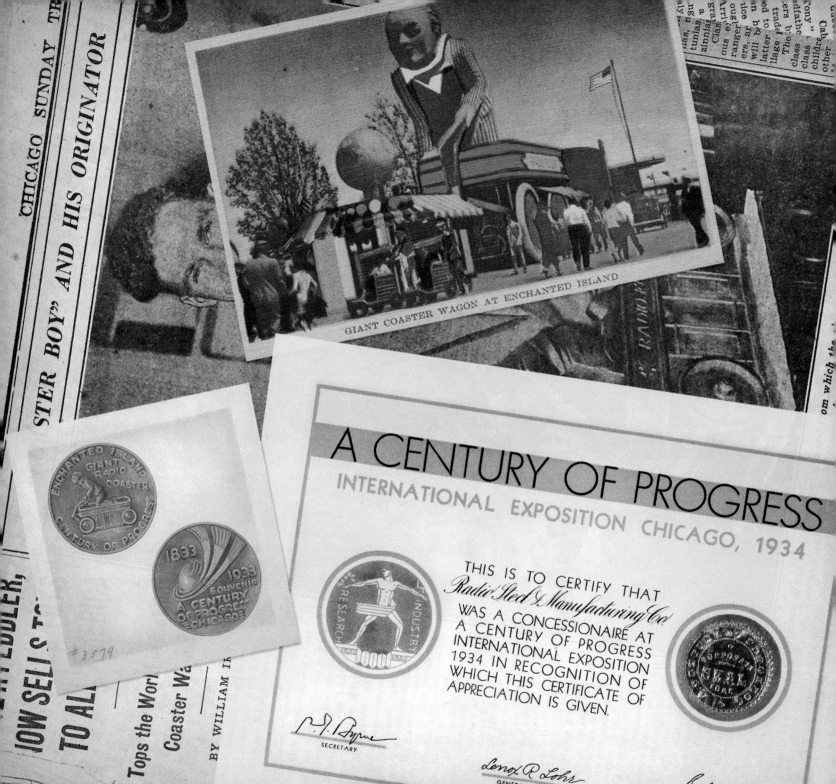

CHICAGO SUNDAY TR...

"STER BOY" AND HIS ORIGINATOR

GIANT COASTER WAGON AT ENCHANTED ISLAND

ENCHANTED ISLAND
GIANT RADIO COASTER
CENTURY OF PROGRESS

1833 1933
SOUVENIR
A CENTURY
OF PROGRESS
CHICAGO

#3579

A CENTURY OF PROGRESS
INTERNATIONAL EXPOSITION CHICAGO, 1934

THIS IS TO CERTIFY THAT
Radio Steel & Manufacturing Co.
WAS A CONCESSIONAIRE AT
A CENTURY OF PROGRESS
INTERNATIONAL EXPOSITION
1934 IN RECOGNITION OF
WHICH THIS CERTIFICATE OF
APPRECIATION IS GIVEN.

M. J. Byrne
SECRETARY

Lenox R. Lohr
GENERAL MANAGER

Rufus C. Dawes
PRESIDENT

EDLER,
OW SELLS
TO ALL...

Tops the World...
Coaster Wa...

BY WILLIAM I...

ONCE A PEDDLER, NOW SELLS TOYS TO ALL AMERICA

Tops the World in Making Coaster Wagons.

BY WILLIAM IRVIN.

When Antonio Pasin arrived in Chicago 17 years ago from Venice, Italy, as a penniless lad of 19 his chief stock in trade was a consuming desire to set up his own business in the shortest possible time. Scarcely did he dream that a scant decade and a half later he would be the world's largest maker of those toys which, perhaps more than any other plaything, are a symbol of all the childhood luxuries he himself had missed — coaster wagons.

A more appropriate symbol of Mr. Pasin's success likewise might not be found than the gigantic coaster wagon and the figure of the boy which towers above all other attractions on the Enchanted island at A Century of Progress. The wagon and the boy, in the characteristic pose of a lad coasting, are a feature of the exhibit of the Radio Steel and Manufacturing company, of which Mr. Pasin is the founder and head. The Pasin toy factory is located at 6041 West Grand avenue and turns our coaster wagons exclusively. The colossal boy coaster at the Enchanted island exhibit has been dubbed "Tony."

Cabinet Maker First.

"Tony" Pasin's father and his grandfather before him were cabinet makers by profession and that was the trade in which young Antonio hoped to gain a foothold in America when he departed from his native Venice with passage money obtained through the sale of the family mule.

Arriving in Chicago the young immigrant lad got a job with his uncle as a water boy in a sewer digging gang. The ambitious "Tony" tarried only long enough in this work, however, for it to fire his ambition for something better, which wasn't long. He got a job as a finisher with a piano company, where he could make use of his knowledge of cabinet making. He got on well and soon was promoted to foreman, but the desire to be on his own, the same courageous spirit that impelled him to seek opportunity in America, drove him into a new venture. He started making phonographs, with little more than nerve and his experience in cabinet making as the sum total of his assets.

Looks for New Venture.

The venture failed and the alert lad looked about for something else to try his hand at. He found it. He came across a chap who had gone broke trying to make coaster wagons. Young Pasin purchased his equipment on time payments and started making wooden coasters in a little one room shop at Grand and Western avenues. He would make the wagons at night and peddle them during the day, toting a sample of his product around in a battered suitcase.

Slowly the business thrived and young Tony took on a helper, which enabled him to turn out an average of five wagons a day. All of the work in making the wooden coasters was done by hand, and here again young Pasin's experience as a cabinet maker served him well. As the retail outlets for his product increased the young manufacturer was able to expand his facilities.

Starts Big Plant.

He moved his business to Mont Clare in 1918 and built the main part of his present factory building "with more nerve than capital," as he puts it. Then came the first big boost for the business, an order from a Chicago jobber for 7,000 wagons.

Today Mr. Pasin's compact factory turns out 3,000 coaster wagons a day and employs 140 men. "I had always wanted to be in business for myself since I was 10 years old," said this genial young toy maker. "I've always liked to see men employed, so maybe that had something to do with my desire to be in business so I could give work to others."

Mr. Pasin made wooden wagons up until three years ago, when he changed his product to steel coasters. Never during the depression, Mr. Pasin said with a touch of pride, did his factory produce less than 1,500 coasters a day.

During the visit of Gen. Balbo and his squadron Mr. Pasin presented the Italian air chief and each of his flyers with one of his tiny World's Fair souvenir coaster wagons painted in Italian colors.

Several years ago he returned to Italy for his childhood sweetheart, whom he brought back to America as his bride. They have twins, three and a half years old, named Mary and Mario.

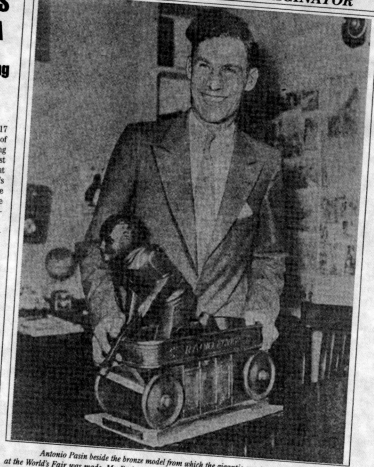

"COASTER BOY" AND HIS ORIGINATOR

Antonio Pasin beside the bronze model from which the gigantic coaster on the Enchanted Island at the World's Fair was made. Mr. Pasin conceived the idea of the huge toy with its boy occupant as a feature of his company's exhibit and had the bronze model made to crystallize his idea.

MODERNISM *and* ARCHITECTURE *at the* WORLD'S FAIR

THE HALL OF SCIENCE SERVED AS THE CORNERSTONE OF THE FAIR, along with nearly two dozen major corporations (compared to only nine at the 1893 fair) that erected their own pavilions and developed displays. The Homes of Tomorrow exhibition featured a twelve-sided home fully equipped with a dishwasher, air-conditioning, and other soon-to-be-commonplace household appliances, encouraging Americans to spend money and modernize everything from their houses to their cars.

The architecture at the fair reflected the same modernist theme, and every building was made to be unique. The sculpture and architectural ornamentation for the Century of Progress was coordinated by Lee Lawrie, the sculptor later responsible for the *Atlas* and other works in New York's Rockefeller Center.

Among the fair's most outstanding structures were Edward Bennett, Hubert Burnham, and John Holabird's massive rectangular midnight-blue, white, and red Administration Building, Alfonso Iannelli's giant Havoline Thermometer, and Raymond Hood's Electrical Building. By all accounts, the Ford Motor Company Building, with its gigantic globe highlighting Ford's operations around the world, was the most popular corporate attraction at the 1933–1934 fair.

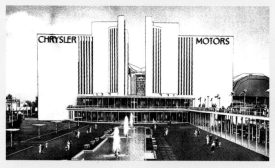

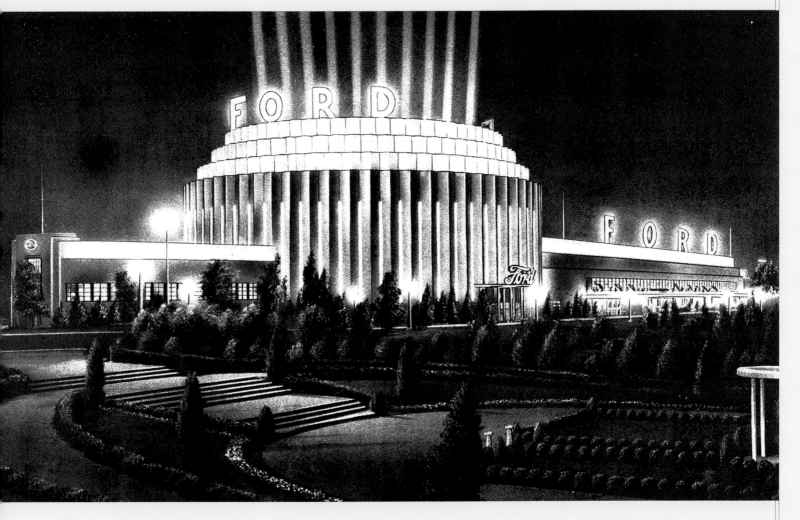

Above and Opposite: Photographs of the Ford Motor Company building and the Chrysler Motors building. Some of the most influential companies at the fair were automobile companies, consistent with the fair's transportation and science theme, which was promoted by the motto: "Science finds, industry applies, man adapts."

"On every occasion I have always tried to show that human progress is as important to me as business profits."

............

— ANTONIO PASIN

MODERN TIMES INSPIRE NEW SPECIALTY WAGONS

T HE WORLD'S FAIR EXHIBIT had made the Radio Flyer wagon a world-famous toy, and the growing company came out with several new ideas to meet demand. As part of the fair's emphasis on advances in transportation, the Union Pacific Railroad Company exhibited its Pioneer Zephyr train, which, on the day before the fair opened, made a record-breaking journey from Denver, Colorado, to Chicago in thirteen hours and five minutes. In honor of this accomplishment, Antonio designed Radio Flyer's first line of specialty wagons, called the Streak-O-Lite, which sold from 1934 to 1936. The sleek new design featured streamlined train styling, an instrument panel of control dials, and working headlights. Next up, Radio Flyer came out with the American Beauty and Zep wagons, inspired by, and modeled to look like, the cool new cars of the time, such as the Chrysler Airflow.

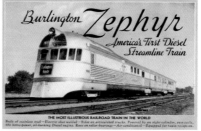

Above: Two of the Pasin children, twins Mario and Mary Ann, test out their father's latest creation, the Streak-O-Lite wagon, in 1936. (Their sister, Jeanette, is not pictured.)
Left: The Pioneer Zephyr Train.

STREAK-O-LITE
Tops Them All!

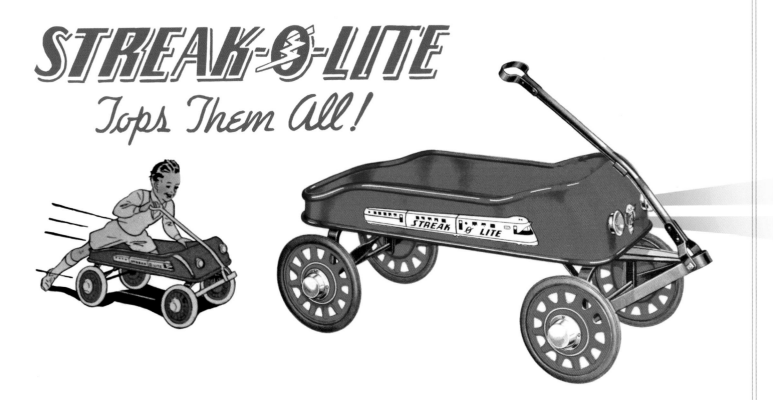

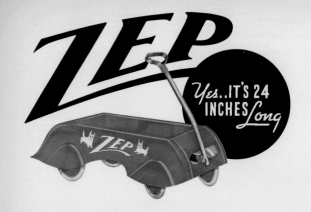

ZEP

Yes.. IT'S 24 INCHES *Long*

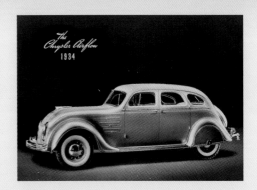

The Chrysler Airflow 1934

Left: The Zep wagon and its design inspiration, the Chrysler Airflow.

RADIO FLYER GOES *to* WAR

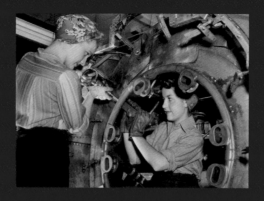

THE UNITED STATES WAS JUST FINDING ITS

way out of the Great Depression when World War II hit. As Americans tuned their radios to listen to President Franklin Roosevelt's address in December 1940, they heard the president appeal to all Americans to rise to the aid of Europe. "The people of Europe who are defending themselves do not ask us to do their fighting," Roosevelt assured his listeners. "They ask us for the implements of war, the planes, the tanks, the guns, the freighters which will enable them to fight for their liberty and for our security . . . We must be the great arsenal of democracy."

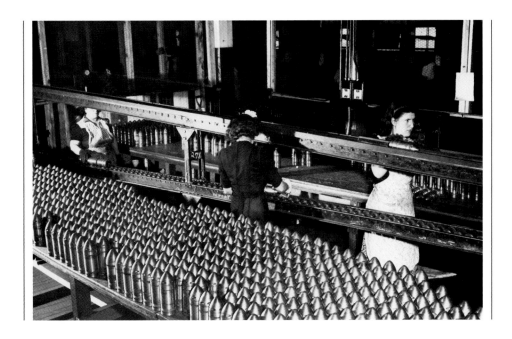

A **YEAR LATER, AFTER THE ATTACK ON** Pearl Harbor, the United States found itself at war, and its production of wartime aircraft doubled. The following year, it doubled again, and by 1945 the country had produced 304,000 aircraft—more than Germany and Japan combined.

It seemed that the weight of the nation's—indeed all of Allied Europe's—chances for victory largely rested on the question of whether or not America could produce enough planes, tanks, and armaments to win the war. Across the country, all materials essential for the war—including rubber, steel, and oil—had started to be rationed so that

they were available for this purpose. The automobile industry, which had manufactured three million cars in 1941 alone, suddenly ceased all regular operations and retooled its factories to manufacture airplanes, tanks, trucks, torpedoes, bombs, and ammunition under large government-issued contracts. Chrysler made fuselages. General Motors made airplane engines, guns, and trucks. Packard made Rolls-Royce engines for the British air force. The Ford Motor Company converted its factories to perform nothing short of a miracle, producing one B-24 Liberator long-range bomber airplane (which had 1,550,000 individual parts) on average every sixty-three minutes at the height of its production.

Above and Opposite: When the United States joined World War II, the majority of fighting-age men joined the Allies in Europe, leaving women to take over their industrial jobs at home in support of the war effort. This phenomenon led to Rosie the Riveter becoming a cultural icon for women during and after the war.

The rationing of rubber and steel also affected the toy industry. Before the war, cast-iron and steel toys, such as Radio Flyer wagons, ranked as favorites among most children. But by Christmas 1942, department-store shelves went bare of all roller skates, metal cap pistols, tricycles—and steel wagons.

Like many other American manufacturers outside of the traditional defense and automobile industries, Radio Steel, as well as other toy companies, such as Hubley, Fisher-Price, Manoil, and Marx, retrofitted its factory to make a wide range of smaller-scale wartime products. Auburn Rubber, which had produced rubber figures and vehicles before the war, manufactured boot soles and rubber gaskets. The A. C. Gilbert Company, best known for its all-steel construction Erector Sets (a kind of precursor to the Lego), designed and produced a new kind of nylon parachute for the paratroopers, a series of range indicators for anti-aircraft guns, trigger mechanisms for land mines, and booby traps to

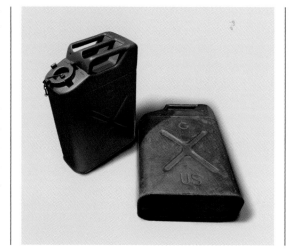

be slipped under doors, into desk drawers, or between books. By the end of the war, the toy industry had supplied the troops with gaskets, fuses for explosives, ship fenders, bomb crates, shell casings, pistol grips, parts for hand grenades, first-aid kits, and any number of other small pieces to support the auto companies' and other wartime manufacturers' production of tanks, trucks, and airplanes.

Antonio Pasin took the call to action seriously. From 1942 to 1945 all wagon

Above: Two stamped-steel blitz cans manufactured for Allied soldiers in World War II. *Opposite:* An Allied soldier carries two blitz cans, likely containing fuel.

production ceased at Radio Steel, and the factory was used to assist in the war effort. However, Antonio requested he not manufacture any weapons or armaments capable of killing. Instead, the War Production Board, which was established by President Roosevelt for regulating all industrial production of war materials, granted Radio Steel a large contract for producing a piece of military equipment called the blitz can. These were five-gallon steel containers that were mounted on the backs of jeeps, trucks, and tanks, and used to transport either fuel or water to troops stationed overseas. Radio Steel's blitz cans saw service in Europe, the Pacific, and Africa.

The war in Europe ended with an Allied victory in May 1945. All told, American industry manufactured almost two-thirds of all of the Allied military equipment produced in the war. In four years, America's industrial production had doubled in size. On July 14, 1945, Radio Steel received an Army-Navy "E" award for excellence in producing essential wartime materials. The war was a pivotal moment for America and an important chapter in Radio Steel's history. The factory and team had performed extremely well (and without compromising Antonio's values), so much so that the military further tapped Antonio and his engineers for hands-on help with safely and properly converting other factories over for wartime production.

> *"Powerful enemies must be outfought and outproduced. It is not enough to turn out just a few more planes, a few more tanks, a few more guns, a few more ships than can be turned out by our enemies—we must outproduce them overwhelmingly."*
>
>
>
> — PRESIDENT FRANKLIN D. ROOSEVELT
> in his address to Congress a month after Pearl Harbor

ALL COMMUNICATIONS SHOULD BE ACCOMPANIED BY CARBON COPY AND ADDRESSED TO

RE PROMPT ATTENTION
IPLYING REFER TO:

NO.

ATTENTION OF

WAR DEPARTMENT
OFFICE OF THE CHIEF OF ORDNANCE
WASHINGTON, D. C.

16 July 1945

JUL 1945
RECEIVED
RADIO STEEL
& MFG. CO.

Mr. Antonio Pasin, President
Radio Steel and Manufacturing Company
6515 West Grand Avenue
Chicago, Illinois

Dear Mr. Pasin:

It is a matter of gratification to all of us of the Ordnance Department that the Radio Steel and Manufacturing Company is to receive the Army-Navy "E" for Excellence. The award typifies the splendid help the men and women of your organization have given the fighting forces.

We of the Ordnance Department are grateful for your fine cooperation and extend congratulations to you and all your co-workers upon this well-merited award.

Sincerely yours,

L. H. CAMPBELL, Jr.
Lieutenant General, Chief of Ordnance

Conco Engineering Works

ARMY E NAVY

In Appreciation to

Radio Steel & Mfg. Co

for the splendid cooperation
which helped make possible the achievement of the

Army-Navy Production Award
for
Excellence in War Production

H. P. Cummy
PRESIDENT

NOVEMBER 18TH, 1943

Above: A Conco Engineering Works award presented to Radio Steel & Manufacturing Company for "the splendid cooperation which helped make possible the achievement of the Army-Navy Production Award for Excellence in War Production."

The TOY INDUSTRY PREPARES *for* BATTLE

CHILDREN LIVING DURING World War II might not have understood all the ramifications of war, but they certainly noticed the change in their toys. Some toys became scarce, while others were made of new materials or had a different appearance.

This meant hard times for many toy manufacturers. Several companies closed their plants, while others did their best to make their former steel and cast-iron figures, trains, and trucks out of other materials. The April 1942 issue of *Playthings* magazine focused on how to successfully adapt product lines, suggesting that manufacturers consider alternatives such as making games and toys using wood.

INTRODUCING
THE RADIO LINE

AT HOME, RADIO STEEL'S WAR efforts sparked a newfound confidence in its line of products. Radio Steel came out with the Radio Line, a modern line of newly minted wagons and scooters. Advertisements for the line emphasized the strength, durability, and dependability of the classic wagons, especially the fact that they were all made as one-piece steel bodies with "no sharp edges. Safe, rounded corners!"

Antonio even tasked a special engineer, Robert W. Hunt, to run a series of tests on a new set of "Congo" bearings for the Radio Flyer's wagon wheels that he could use to guarantee their longevity to his customers. One of the tests spun the wheel at a velocity equivalent to ten miles per hour with a twenty-pound load per wheel. After 1,000 miles, Hunt reported that the bearing had jiggled an imperceptible 0.0016 inches closer to the center of the wagon's axis. After 2,500 miles, that number was 0.0026 inches, and after 4,000 miles, 0.0028. To Antonio's great satisfaction, Hunt's report concluded, "At the end of the running of 4,000 miles, the bearing still worked more than satisfactorily." After the tests were a success, Antonio included a lifetime guarantee for all Congo bearings with every wagon.

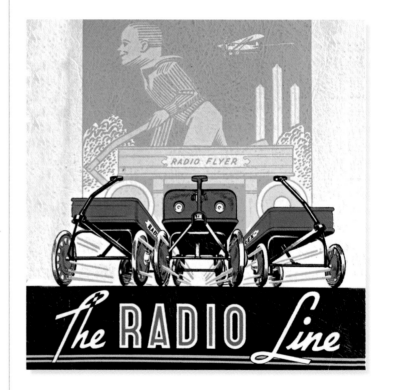

Above: The cover of the 1946 catalog for the Styled in Steel Radio Line.

Styled in Steel

Main Office and Plant of RADIO STEEL & MFG. CO. — 6515 W. Grand Ave. — CHICAGO

World's Largest Exclusive Manufacturers of Coaster Wagons — Phone: MERrimac 7100

NO SHARP EDGES · SAFE, ROUNDED CORNERS

Above: A postcard with a rendering of the main office and plant of Radio Steel & Manufacturing Company on West Grand Avenue.

BABY BOOM

When World War II ended,

the United States was in a better economic condition
than any other country in the world. All the nation's
efforts to bring about victory during the war had pulled
it out of the Depression years, and new financial initia-
tives and an increase in manufacturing set the stage for
the greatest, and longest, economic boom the country
had ever seen.

AFTER THE WAR, ALL RATIONING WAS lifted, and the newly elected President Truman reduced taxes to encourage consumer spending. The GI Bill of Rights allowed veterans to go to college and provided low-cost loans for them to buy homes and farms. Prosperity and overall optimism made most people feel it was a good time to bring children into the world, and so, as twelve million veterans returned home, they focused on family and began having children in record numbers. Cue the arrival of America's largest generation yet: the baby boomers.

The growing population of American middle-class families also presented a prime opportunity to real estate developers. Developers went on a buying spree, purchasing empty land on the outskirts of cities, where they mass-produced inexpensive tract houses. This ignited a mass exodus of families from the cities to the suburbs. By 1950, more Americans lived in the suburbs than anywhere else in the country.

The most famous housing development created during this time was Levittown on New York's Long Island, which turned four thousand acres of potato fields into the largest private housing project in United States history. For a total price of ten thousand dollars (or one thousand down, and seventy dollars a month),

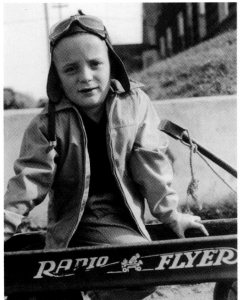

Above: A boy in an aviator cap gets ready to take flight in his beloved Radio Flyer. *Opposite:* An image of suburban life and play with a Radio Flyer wagon from *Better Homes and Gardens* magazine (1953).

residents of Levittown could walk into a new house with three bedrooms, a fireplace, a gas range and furnace, and a landscaped lot of seventy-five by one hundred feet of healthy lawn. For a generation that had survived the Great Depression and World War II, these houses felt like a lavish luxury.

The move to suburbia also created a new, car-dependent lifestyle, which increased demand for automobiles. Shopping malls and chain stores began cropping up to provide the goods residents would need to fill their new homes. Most notably for Radio Steel, a backyard of one's own brought demand for new products, such as lawn mowers, gardening gear—and wagons.

Keeping with the times, Radio Steel—now almost forty years old—switched from its wartime manufacturing back to making its trusted little red wagons, and even expanded to selling gardening wagons for adults, too. Sears, which was also headquartered in Chicago, was Radio Steel's largest customer, and the company grew as the retailer expanded into malls. The shift in the country sparked a shift for the company, as Radio Steel expanded to meet consumer demand and secure its name in households across America. Sales quadrupled from 1946 to 1960. Antonio Pasin's slogan "For every boy. For every girl" was quickly becoming a reality for America's growing families.

DOWN THE GARDEN PATH

"No feature of a suburban residential community contributes as much to the charm and beauty of the individual home and locality as well-kept lawns."

—ABE LEVITT, in a newsletter to Levittown homeowners

THE CLASSIC IMAGE OF A SUBURBAN home is incomplete without that perfectly square parcel of green lawn bordered by a white picket fence. Such a well-manicured lawn required its owners to invest in its care. In Levittown, there were strict rules about how to keep one's lawn. New homeowners were given pamphlets and flyers about the importance of maintaining a perfect lawn, with plenty of tips for how to keep it lush, green, and healthy. Unlike in Europe, where lawns were bound behind high hedges, American lawns were supposed to be open and friendly, a place to convene with family and friends.

Many companies saw this space as a ripe opportunity, and launched new lines of products for its cultivation. In 1953, manufacturing company Briggs & Stratton created the lightweight aluminum engine for mowers; just four years later it represented 80 percent of the engines the company shipped in the United States.

In 1957, Radio Steel introduced a line of garden carts to help out with lawn care in the nation's fast-growing suburbs. A letter to wholesale buyers in October 1957 announced: "The race for ranch homes—has created an unprecedented market for lawn and garden needs. Matter of fact, our forefathers ran whole farms with a lot less equipment than the modern man needs to run a lawn . . . So it is with high excitement that we proudly announce the sensational new Model #75 Radio Line Garden Cart!"

Elegant, strong!

Cable: RADIOFLYER, Chicago

RADIO STEEL & MFG. CO

WORLD'S LARGEST MANUFACTURERS OF COASTER WAGONS AND SCOOTERS

REX LINE

6515 West Grand Avenue • Chicago 35, Ill. • MErrimac 7-7100

Best of
October

THE RACE FOR RANCH HOMES --

has created an unprecedented market for lawn and garden needs.
Matter of fact, our forefathers ran whole farms with a lot less
equipment than the modern man needs to run a lawn.

Heading his list is a garden cart. But all the existing carts
- 'til now - have left much to be desired. So it is with high
excitement that we proudly announce the sensational new

MODEL #75 RADIO LINE GARDEN CART!

Here is a fresh new concept in garden carts - based on years of
research and development - so easy to use that women love it -
so ruggedly designed that men can't resist it.

Here is a garden cart that wins instant allegiance - one item -
indispensable - with utility and service for all.

Look at the picture. Can't you just feel the appeal these red
and blue beauties will have on your sales floor?

Everyone sees at once that the cleverly recessed wheels will
put an end to snagged slacks and skinned shins - that the air-
cushioned tires will float loads over lawns without damage.

Then it's easy to roll out the dotted line with such clinching
features as the solid, one-piece steel body with beaded edges -
the tubular steel handle - and easy-rollin' lifetime bearings.

Get this hot one for early Spring sales. It's new - it's dif-
ferent - it's ideal! Even the man who has everything can use
this cart to put it in!

Remember, one million new homes being built every year, so get
those extra sales on a solid selling staple. Grab a pencil,
write up an order, and we'll give you prompt service!

Enthusiastically yours,

E.W. Wallgren

Wheeling Forward for
RADIO STEEL & MFG. CO.

P.S. Oh yes, your price on model #75,
packed two, FOB Chicago is $4.60
packed one, " " is $4.90

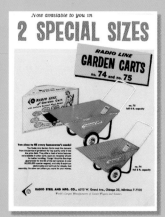

Above: Advertisements for Radio Steel's new line of Garden Carts placed in wholesale catalogs. *Left:* Letter to wholesale buyers announcing the newest addition to the Radio Line: a Garden Cart wheelbarrow, inspired by the "race for ranch homes."

Antonio's son, Mario, a fresh graduate of the University of Notre Dame, collaborated closely with his father on the development of the Garden Cart. The model featured a large body with a low center of gravity and four-cubic-foot capacity, special 9½ by 1½–inch Radio Line wheels with extra cushioning, and the signature Radio Line Congo graphite bearings. This design made it easier to carry a larger load in a smaller area—its heavy steel construction and baked enamel finish also added to its durability.

The patented design allowed for the carts to be stacked when fully assembled, which made for impactful point-of-purchase displays at all of the new suburban Sears stores. The packaging was also new for the garden department. Whereas previously wheelbarrows were sold in parts at hardware stores and then had to be assembled, Radio Steel's Garden Cart contained all parts in a single package with graphics and feature callouts, making it easy for any suburbanite to pick one up at the local mall.

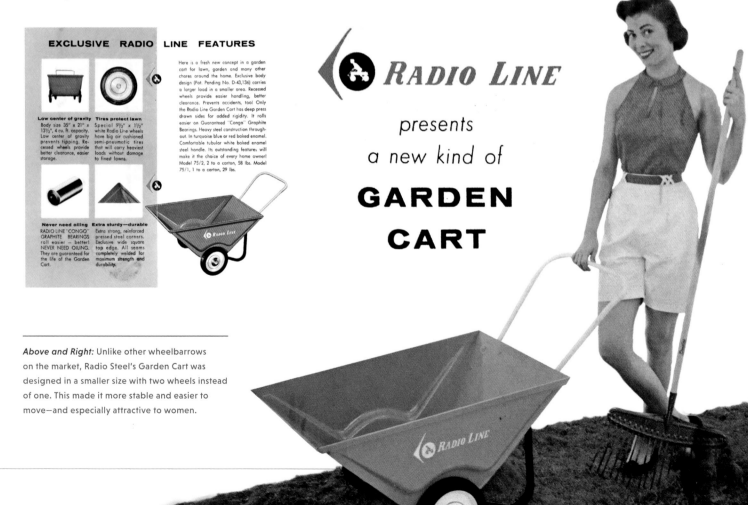

Above and Right: Unlike other wheelbarrows on the market, Radio Steel's Garden Cart was designed in a smaller size with two wheels instead of one. This made it more stable and easier to move—and especially attractive to women.

A CENTURY OF SMILES

RADIO FLYER STORIES

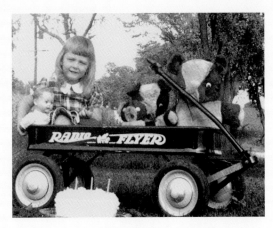

This photo was taken September 19, 1950. We lived in a small rural town in Wisconsin, and money was scarce, to say the least. That year, my father made several sacrifices to see that I had a Radio Flyer wagon for my birthday. I loved it, and used it for hauling teddy bears, baby chicks, kittens, and puppies. Later, I used it to haul hay bales to feed thirty head of cattle. I left home in 1965, and left my beloved Radio Flyer wagon to be handed down to my younger sister and brother.

—BARBARA DAWN M.
Morton Grove, IL

During 1953, while my husband served in the U.S. Army, I clerked at our neighborhood grocery. The storekeeper allowed me to bring my youngster with me, and my mother picked him up at noon. Little Kevin loved his daily ride in Grandma's Radio Flyer, but on the way home one day, she heard some pitiful whimpering behind her. When she looked back, her precious grandson was on the sidewalk—he had tumbled out when the wheel hit a crack! Grandma lovingly cuddled him, but he wasn't pacified until she placed him back in the wagon to ride some more.

—PATRICIA L. • Pinellas Park, FL

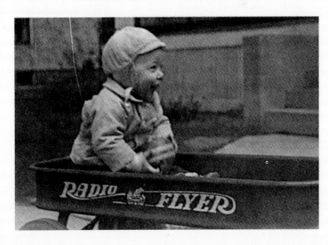

THE RADIO LINE

★ ★★ FOR 1950 ★★ ★

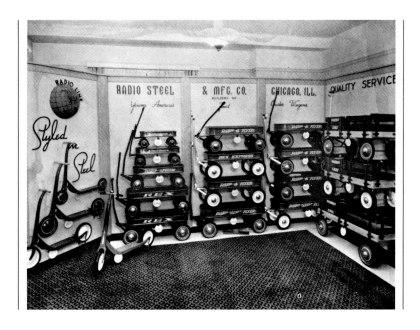

RADIO LINE: STILL FLYING STRONG!

THE RADIO LINE WAS ALWAYS RADIO Steel's flagship line, and sales remained strong. With a dozen best-selling models—ranging from the largest all-purpose Radio Rancher and Radio Chief wagons, new additions to the line, to the classic, signature Radio Flyer with Congo graphite lifetime bearings and sparkling white enamel wheels, to the compact Radio Tot for the company's youngest customers—the Radio Line had a model for everyone. You could even pick out your favorite of the new two- and three-wheeled scooters, which came complete with white enamel fenders, a parking stand, and a brake.

Above: The Radio Steel showroom, displaying the Styled in Steel Radio Line, which had expanded to over a dozen models in various shapes and sizes—all painted in Radio Steel's signature red. *Opposite:* A catalog spread announcing the 1950 Radio Line series.

With production and sales booming in the 1950s, Antonio decided to introduce several new products to the Radio Line, trying out not only limited specialty wagons, but also all-new designs.

Radio Line

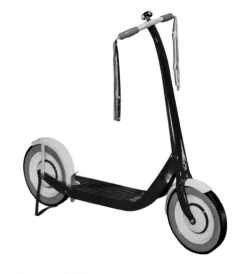

Radio Imperial Scooter

Made from one stamped piece of heavy-gauge steel with an embossed footrest, the Radio Imperial Scooter was the talk of the neighborhood for its shiny white, red, and turquoise-blue design. The scooter came complete with a parking stand and back brake, and the Radio Line's signature air-cushioned, automobile-quality tires.

Radio Rancher

The Radio Rancher (Model No. 19) was the standard-size, all-purpose wagon of the premier Radio Line. With super air-cushioned, tire-like wheels, the Rancher was specially designed for a smooth ride on the front lawn or for work around the home or farm.

Radio Chief

With convertible sides, Congo graphite bearings, and a large steel bed, the Radio Chief (Model No. 22) was the biggest and sturdiest of the Radio Line wagons—"excellent for newspaper delivery."

THE REX LINE

WHEN COMPETITORS tried to come out with less expensive products, the company launched the Rex Line, which sold for the lowest price on the market. Antonio created the Rex Line to be slightly "de-specced," with pressure-packed ball bearings as an inexpensive alternative to the Radio Line's signature Congo graphite bearings, and a minimalist design to save on materials. Since it was slightly lower quality than the Radio Line, Antonio wanted to use a different name to differentiate it from the flagship. He chose *Rex*, Latin for "king," as a signal to competitors that he was going to be the king of the wagon business, so they shouldn't try to beat his price.

Right and Opposite: In the 1950s, Radio Steel came out with the Rex Line as a lower-price alternative to its premier Radio Line. By focusing on fewer models and a simpler overall design, Radio Steel could offer good-value wagons to more families—and compete with other companies that were selling lower-quality wagons at a lower price point.

The REX LINE

COASTER WAGONS *and* SCOOTER

REX "90" (Model No. 90)

Trim—dashing in appearance. A full size top quality wagon for the young speedster.

BODY	34" x 15½" x 3¾"
WHEEL	8¼" double disc
TIRES	8¼" x 1.25" Semi Pneumatic
BEARINGS	Famous Congo "Lifetime" Bearing
FINISH	Baked Enamel, body red, wheels gray
AXLES	½" round
PACKING	24 lbs., packed one to a carton.

Sensational News!

REX "90"

REX LINE

ALWAYS A FAMILY COMPANY

DESPITE ALL OF THE CHANGES IN THE country since the company's start, Antonio continued to prioritize incentives that made working at Radio Steel feel like being part of a big family. By the mid-1950s, it had become common for employers to offer basic employee insurance and pension plans, but Radio Steel went well beyond that. Employees enjoyed an array of unusual benefits: Midday movies, personalized birthday cards from Antonio himself, Friday-night dances, big parties, company picnics, and, of course, a state-of-the-art cafeteria with an Italian chef were just a few of the benefits employees were given during this time.

As always, behind these great company perks was a deep-seated respect for the worker. Antonio had experienced firsthand the drain in morale that comes from poor or unsafe working conditions and uncertain wages. In building his company and expanding its headquarters in 1948, he made a point of incorporating every modern convenience and assurance possible for his workers. The factory offices were well equipped with air-conditioning, and the modernized

Above: Radio Flyer workers bring the spirit around the holidays. *Opposite:* Antonio with two of his children, Mario and Mary Ann, at the annual New York Toy Fair (1950).

cafeteria used the latest appliances, which allowed it to offer employees food and drink at half the cost. Antonio was particularly conscious of making the factory completely safe, running extra tests and inspections on every piece of equipment and power station before allowing employees to use them. So high were his standards that the American Anti-Accident Association started to use the Radio Steel & Manufacturing Company as a model for other plants. Employees who never had any type of safety accident were even offered rewards (until so few employees had accidents that the prize was rendered irrelevant).

All employees could take advantage of housing plans and were guaranteed an annual increase in pay. Special exemptions and less physically taxing roles were set aside for people who were older than fifty years of age, and, against the predominant opinion of the time, Antonio encouraged the hiring of current employees' working-age children to join their parents in the factory as well. "I gladly hire my workers' sons," Antonio wrote of this policy. "To see the family grow means everything to me." Working at Radio Flyer truly was a family affair.

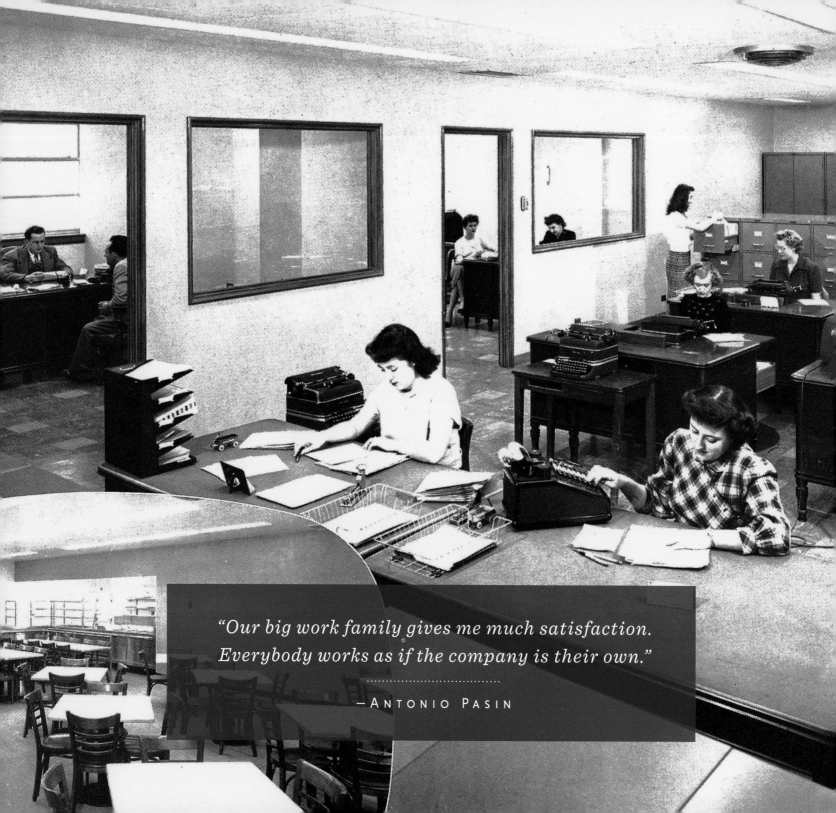

> "Our big work family gives me much satisfaction. Everybody works as if the company is their own."
>
> —ANTONIO PASIN

A CENTURY OF SMILES

RADIO FLYER STORIES

In 1944, World War II was coming to a close, but money was still not available for anything other than basic necessities. But how could a five-year-old boy live without a Radio Flyer? Daily, I would walk by Jimmy's Toy Store and gaze tearfully at that beautiful red wagon sitting in the window with the price tag of $15.50 hanging from the rear wheel. But Dad had said no—we couldn't afford it. I really understood. In the early years of the war, we hardly had enough food to eat—so a wagon was unnecessary. But I had a plan. I asked Mr. Jimmy at the toy store if I could pay him two pennies a week (my allowance) until the bill was paid. Believe it or not, he actually said yes. As my allowance increased, I increased my weekly payment until the $15.50 was paid in full. I never missed a week and I never missed the candy I would have bought had I kept my allowance.

Fifty-four years later, when my son was almost five years old, he asked me to buy him a Radio Flyer that he saw at our local department store. He must have it, he told me, and we *can* afford it, he added. "Maybe so," I replied, "but it will cost you two cents a week from your allowance until you are all paid up."

"Are you kidding, Dad?" "No, son," I said. "Let me tell you a story that took place long before you were born. The year was 1944 . . ."

— NORMAN L. • Encino, CA

Above: A collection of snapshots of employees in the company cafeteria and storage area circa 1970. *Opposite:* A photograph of the general office at Radio Flyer.

GETTING *the* WORD OUT

THE 1960S AND '70S WERE YEARS OF

cultural and political revolution—Americans witnessed the civil rights movement, listened to groundbreaking music, made strides toward landing on the moon, and became embroiled in the Vietnam War. It was a time of radical change. Young women read *The Feminine Mystique*, celebrated the passage of the 1963 Equal Pay Act, and joined the National Organization for Women. Hippies, part of a new counterculture youth movement, abandoned the idealized suburban life that had defined the 1950s and embraced freer ways of living.

THE TOY INDUSTRY CHANGED AS well. A shift in popular culture, mostly inspired by television and film, altered the image of childhood and gave boys and girls a whole new set of role models. Boys became more likely to look up to popular figures like Fonzie or Elvis instead of engineers and inventors like Thomas Edison or Henry Ford. Toys that were designed to promote engineering skills, like Erector Sets, Lincoln Logs, and Tinkertoys, declined in popularity throughout the 1960s and '70s. The A. C. Gilbert Company, the maker of the Erector Set and once one of the largest toy companies in the world, struggled after the passing of its founder, and went out of business. Louis Marx & Co., one of the best-known toy companies throughout the 1950s, was sold to the Quaker Oats Company. Girls' toy trends similarly shifted away from dollhouses and baby dolls to toys with more high-tech features, like Chatty Cathy and the Easy-Bake Oven.

Above: "The times they are a-changin'": New toys like Atari and Twister defined a new era. *Opposite:* Singer and songwriter Bob Dylan grew in popularity during the political revolutions of the '60s and '70s, especially among young people looking for change.

While some of the largest and oldest toy brands fell by the wayside, others offered fad toys inspired by TV or film, or changed course to take advantage of new and less expensive synthetic materials. This was also the era of the Nerf Ball, the birth of Dungeons & Dragons, and the rise of Twister, which became an overnight sensation after Eva Gabor played it with Johnny Carson on The Tonight Show in 1966. The end of the 1970s brought the Atari 2600 and Star Wars action figures. But as many new classics were born, fads came and went in the form of mood rings and pet rocks (which came with a thirty-two-page training manual).

In this time of rapid change, Radio Steel & Manufacturing forged onward, innovating new products and designs. The company adapted to incorporate new popular styles, without compromising on the promise to offer consumers a high-quality product at a low cost. Staying true to its core values, the classic little red wagon company deftly steered the new course ahead.

ADVENTURES IN TELEVISION

DUBBED BY MANY HISTORIANS AS THE "Golden Age of Television," the 1950s and '60s saw the number of television sets in the country rise from fewer than ten thousand in 1945 to sixty million in 1969.

Just ten years later, 96 percent of all American households owned at least one television, and they could watch shows on more than seven hundred commercial TV stations. Television swiftly became the leading national ad medium in the United States, surpassing radio and magazines as a way to stream ads directly into families' homes at every hour.

In response to television's explosive popularity, some of the largest toy companies also took to the small screen. Television became the place where the new, trendy toys were advertised: Hasbro ran local TV advertisements for Mr. Potato Head in 1951. Mattel, which launched the iconic Barbie doll in 1945,

became a major advertiser on *The Mickey Mouse Club* in 1955.

Amid the frenzy to advertise on TV, Radio Steel & Manufacturing held steadfast to the belief that the best marketing was the product itself and word-of-mouth promotion by consumers who loved it. Antonio had always believed it was most important to keep the price of the product low, which precluded purchasing any major advertising spots—there simply was no margin to do it, since all the money went into building a quality product. Instead, Radio Steel took to the times in its own way. Radio Steel maintained an unwavering focus on the product, and incorporated the trends by designing specialty wagons inspired by some of the most popular movies and TV shows of the time, such as *The Mickey Mouse Club, Davy Crockett,* and *Zorro*. With these new wagon designs came new catalogs, brochures, and packaging. Business boomed.

Above: Television watching became a popular pastime for friends and family after work or over the weekends. *Opposite:* Product ads for Radio Steel's Davy Crockett, Mouseketeer, Disney character Tiny-Tot, and Zorro coaster wagons—all inspired by some of the most popular TV shows and characters of the 1950s and '60s.

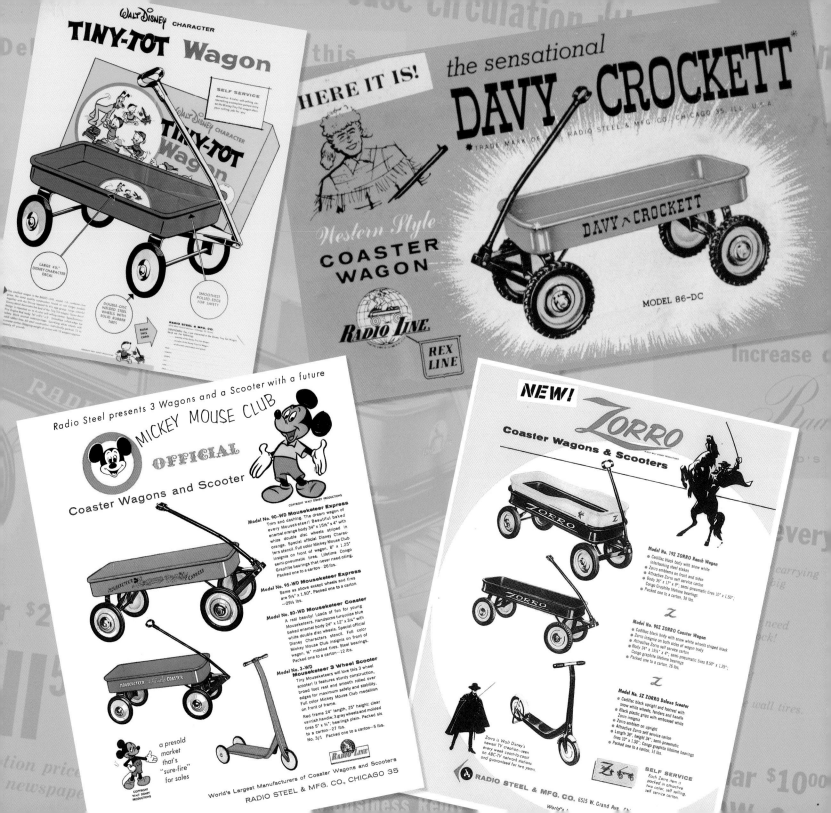

SEASON'S GREETINGS

WORLD'S LARGEST MANUFACTURERS OF COASTER WAGONS AND SCOOTERS

It is a time to re-live the past - risk a dream of the future - and be grateful for the gift of friendship.

So it is with deep appreciation of cordial relations in days gone by and pleasant anticipation of those to come that we say - sincerely -

May your holidays be as bright as a star - cheerful as a sleigh ride - and calm as a snowy night!

Faithfully yours,

E.M. Wallgren

RADIO STEEL & MFG. CO.

EMW:jh

Yuletide 1956

RADIO STEEL & MFG. CO

LETTERS FROM RADIO FLYER

WITH SO MANY NEW PRODUCTS on the market, toys were being mass-produced, mass-bought, and mass-sold like never before, and the traditional connection between individual toy manufacturers and retailers weakened. Staying true to the belief that the products would continue to speak for themselves to customers, Radio Steel focused on strengthening its direct relationships with individual retail buyers to guarantee that its wagons, scooters, and other ride-on toys would get premium positions in retail stores across the country. Radio Steel took out print ads in retailer catalogs and newspaper circulars.

Radio Steel's sales manager, E. M. Wallgren, decided with Antonio to double down on the connection with retailers through regular correspondence. In the 1930s, Radio Steel began to send letters to its wholesale buyers a few times a year. By the 1950s and '60s, Wallgren took the lead in distributing letters every month, sometimes two or three times a month, to a widening network of both small and large retailers across the country. These letters were chock-full of personality and company updates—announcements of new products, company milestones, sales tips, and even best wishes on holidays, and they always thanked the buyers for their loyalty. These letters helped to remind the individual salespeople and their managers that they were a part of the Radio Steel family.

Despite the company's not having advertised on TV or invested the same kind of ad dollars as other popular toy companies, little red wagon sales soared, surpassing fifty million wagons sold by the end of the 1950s. Antonio's simple strategy of hyper-focusing on individual retail relationships worked, without his having to compromise on the quality of the product itself. The product acted as its own advertisement—the bright red wagon with the huge white logo served as its own little billboard on millions of American manicured lawns. The 1950s and '60s, which proved a challenge for many other small toy companies, only continued to cement the little red wagon's status as an American icon and a hardy American toy: "Sooner or later you'll have to buy the kids a big red coaster wagon. (This probably is a factor in their growing up to be 100% pure red-blooded American)," stated a 1953 ad in the *Pharos-Tribune* of Logansport, Indiana.

Above: Radio Steel & Manufacturing's official letterhead circa 1955.
Opposite: A letter from Radio Steel & Manufacturing Company to wholesale buyers nationwide. Radio Steel kept a regular monthly correspondence with its retail buyers and salespeople, sending company updates, holiday wishes, and sales tips.

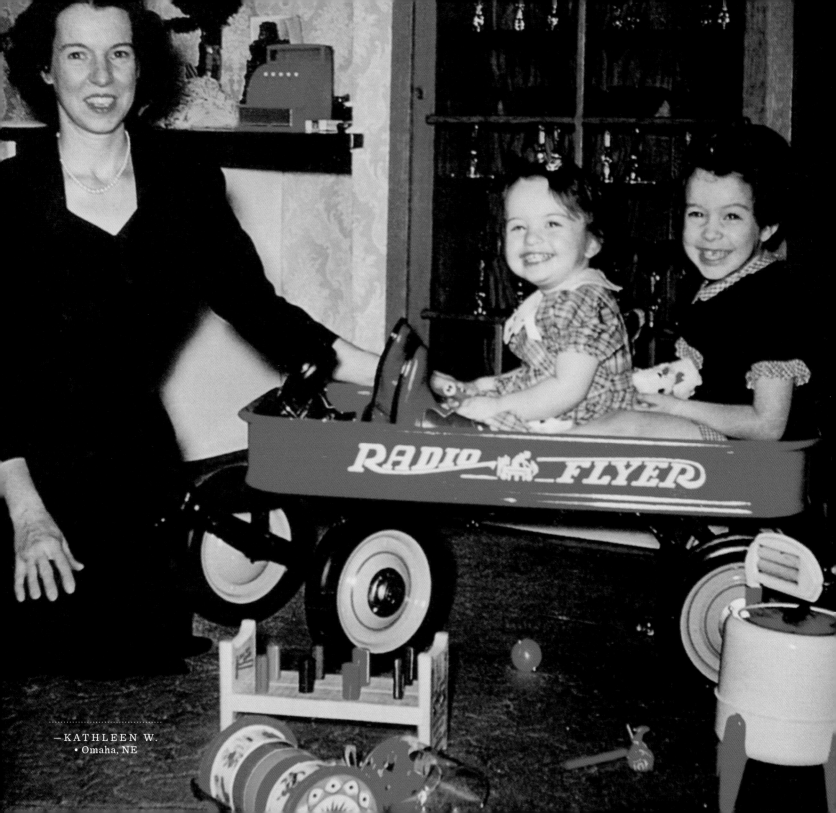

When I was four, my father took me for a walk every evening. One night, I noticed a bright red wagon inside the garage of our neighbors, an elderly couple I'd never once seen smile. Tugging my dad's sleeve, I asked if we could borrow it, but he said no, that it didn't belong to us. Each evening after that I begged again. "I'm sorry," he would say.

When Dad asked what I wanted for my fifth birthday, I told him I only wanted to take walks together. That night the old man was outside, and for once I didn't ask about the wagon. Suddenly Dad stopped, led me back to the man's yard. He introduced himself and explained about the wagon and my request.

The man's stern look melted. His eyes grew moist. He told me that the wagon had belonged to their only child, Hardy, and that leukemia had taken the boy when he was seven. Old Mr. Griffith looked down at me, smiling through his pain. He said he wanted me to use the wagon because his son no longer could, and right there he gave me Hardy's Radio Flyer.

From then on, the wagon became part of our nightly walks. More important, I adopted a "grandfather" whom I grew to love. I now use Hardy's classic Radio Flyer—still in fine working order—to pull my own son, Dakota. Much more than a childhood toy, to me it represents the priceless bond between father and son—and the importance of enjoying this gift while we can.

—TIM S. • Santa Monica, CA

A CENTURY OF SMILES
RADIO FLYER STORIES

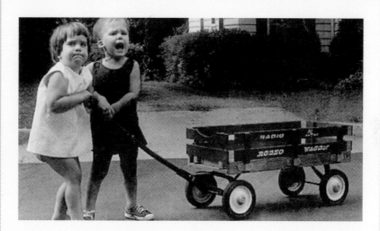

Everyone wanted to pull the bright red Radio Flyer! My husband and I laugh when we look at this picture from the summer of 1970 and see how much our son Robert, who is almost three years old, is strong-willed like I was when I was younger. He, of course, has his own Radio Flyer just like the one pictured—the fun and memory-making continues!

—EVELIA KAYLINA C. • Palm Bay, FL

If Norman Rockwell had designed a wagon, I don't think he could have done better than the Radio Flyer. It is Americana on four wheels. Our wagon did service for eleven kids, and survived everything we could dream of throwing at her. She carried everything from Barbies to bricks. She was a go-kart and a grocery cart. A spaceship and a magic carpet.

—CHRIS W. • Carpentersville, IL

RADIO STEEL GETS A NEW LOOK

CULTURE AND CONSUMPTION CHANGED drastically throughout the 1960s and '70s, and so did style. Bold colors, straight lines, and go-go boots were in. Radio Steel kept pace, with its own stylistic overhaul. The year 1967 was the golden anniversary of Radio Steel, and with business stronger than ever, the company decided to give itself a complete makeover. The wagons were still made with the same quality craftsmanship and care that had become trademarks of Radio Flyer, but new technologies allowed for even greater expansion of the Radio Line. In addition to a number of new products, three new logos were designed.

Above: Radio Steel developed a new set of logos—one specifically celebrating the company's golden anniversary in 1967 with a simple, modern typeface framed in gold. *Right:* The 1970s ushered in a new style of colorful and playful ad designs. *Opposite:* While Radio Steel & Manufacturing Company had been commonly referred to as Radio Flyer for decades, it wasn't until 1987 that the company name was officially changed to Radio Flyer Inc., in honor of the famous little red wagon.

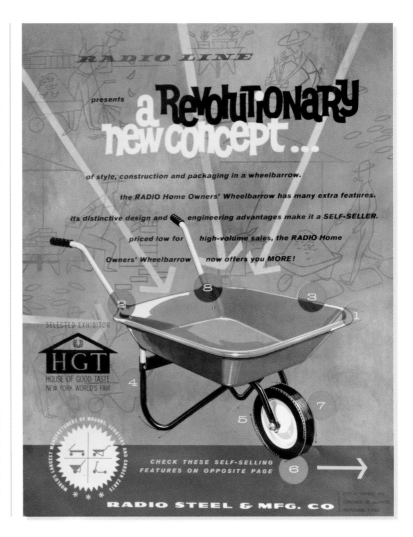

1917	·LIBERTY·COASTER·	1967	RADIO
1930	Radio Steel & Mfg. Co. Telephone Berkshire 2727-28 General Offices and Plant 6041-51 West Grand Avenue CHICAGO	1987	RADIO FLYER
1940	RADIO STEEL & MFG. CO. 6515 W. GRAND AVE., CHICAGO	1992	1917-1992 RADIO 75TH FLYER. ANNIVERSARY
1941	RADIO STEEL & MFG. CO. 6515 West Grand Avenue, Telephone Merrimac 7100 CHICAGO. ILLINOIS. U. S. A.	1997	1917·1997 80 YEARS AMERICA'S ORIGINAL LITTLE RED WAGON
1945	RADIO LINE	1998	RADIO FLYER
1950	RADIO FLYER	2000	America's Original Little Red Wagon Since 1917 RADIO FLYER Trademark
1958	RADIO STEEL & MFG. CO.,	2002	RADIO FLYER
1961	radio flyer	2010 to Present	RADIO FLYER.

PACKAGING FROM THE 1960s

PACKAGING SIMILARLY changed to streamline messaging and incorporate bolder colors. The wagons, scooters, and wheelbarrows of the classic Radio Line now all came in similar eye-catching boxes designed in black, white, and "Radio Flyer Red," and sported the new company logo. A handy description of all of the parts each box contained was listed front and center on each self-service carton, allowing customers to see that they could take it all home in one piece.

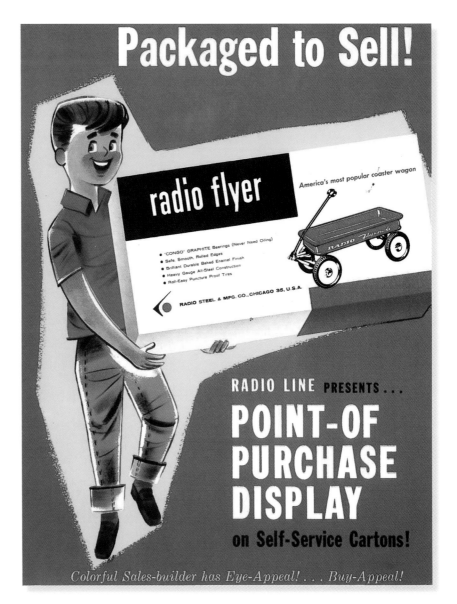

Above and Opposite: In the 1960s, Radio Steel developed all-new packaging for its Radio Line products, designed for easy point-of-purchase display.

Safe, Healthy, Outdoor Fun for

RADIO

'76 ★

RAD ADS

MORE DYNAMIC AND colorful illustrations were also used in the company's advertisements, but the message never wavered—high-quality products "For every boy. For every girl." One advertisement from 1973 deemed the Radio Flyer the "only wagon that outsells Ford station wagons." This was part of an innovative promotion in conjunction with Ford where a Radio Flyer wagon was "sold" for a penny with every Ford station wagon. Ford bought a lot of wagons from Radio Flyer!

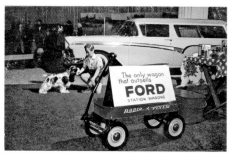

Above: One of the most popular ads from the 1970s boasted Radio Flyer was the only wagon to outsell Ford station wagons. At its peak, one out of every five cars sold in America was a station wagon. *Opposite:* In the 1970s, Radio Steel developed a new collection of colorful and playful ads to match the "rad" times.

RADIO FLYER IN POPULAR CULTURE

AS THE FREE-SPIRITED 1970S CAME to a close, the 1980s began a period of decadent consumerism. The baby boomers, who had been children in the wholesome 1950s and '60s, had grown up and were at the height of their spending years, which contributed to an increase in materialism and an influx of new consumer products. Shopping malls began popping up everywhere. The booming economy led to the birth of new technologies—from video games to personal computers to synthesizers in every band—earning the decade the nickname the "go-go eighties."

There was an explosion in pop culture, as new shows, movies, and music artists were disseminated to the general population like never before. Television continued to thrive, particularly with the emergence of cable networks, like MTV, which introduced the music video, and the rising popularity of the VCR, which allowed families to watch the latest blockbusters from the comfort of their own homes.

Above: Radio Flyer wagons have appeared in dozens of TV programs and movies.

Toy companies responded to this growing interest in consuming popular culture with their own discovery—licensing. Licensing was nothing new, but it reached a whole other level of relevance as toy companies released lines of dolls, vehicles, and action figures modeled after the nation's most popular new films, shows, songs, and characters. Star Wars action figures flew off the shelves, along with E.T., Smurfs, Garfield, Transformers, and Pac-Man dolls. For Radio Steel & Manufacturing, the decade was similarly full of partnerships with kid-friendly shows and brands, and myriad new products to reflect the era.

By the 1980s, the Radio Flyer wagon had truly become an American classic, and it was often used as a recognized symbol of childhood in movies and shows. The company always gave products free of charge to prop houses, and when they needed a toy they would grab a Radio Flyer, which had become a ubiquitous part of American scenery and was often a feature in the ideal yard.

Left: In the 1992 drama film *Radio Flyer,* directed by Richard Donner and starring Tom Hanks and Elijah Wood, two brothers grow up together with their little red wagon. At the film's end, one of the brothers flies to safety in a Radio Flyer wagon converted into an airplane.

—BRIGID W. • Longmont, CO

A CENTURY OF SMILES
RADIO FLYER STORIES

My son was born with deformed lenses in both eyes, which made him blind. Shortly after his first birthday, he began the first of ten major surgeries he would need before age two and a half. We had gotten him a little red Radio Flyer wagon for his birthday. We filled it with a blanket and toys and used it to pull him all over the hospital. He was too busy laughing and having fun to think about what was happening there. Because of the wagon, there were less tears (mine and his). Many years later, we are now busy restoring a Radio Flyer for my grandson's first Christmas. I have decided that EVERY grandchild I have will receive a Radio Flyer!

—CHRISTIE B.

Since my husband and I both grew up with Radio Flyers, we knew that when our son turned one, we would buy him one—you can't ever be too ready for your first red wagon! Ever since then, he has pulled his toys around in it and used it as a space to "read" his books.

—MICHELLE P. • Mission Viejo, CA

119

NEW WAYS TO FLY

AS BEFORE, RADIO FLYER CONTIN- ued to innovate with new product ideas and specialty lines designed to reflect the times. Kids could fly in their Radio Flyer Ski Sleds during the Winter Olympics, race in their muscle-car- and Motocross-inspired wagons, or ride along in their very own construction-inspired wagons. For the younger tots, there were new ways to ride, wiggle, row, and even learn how to walk, using their Radio Flyer vehicles.

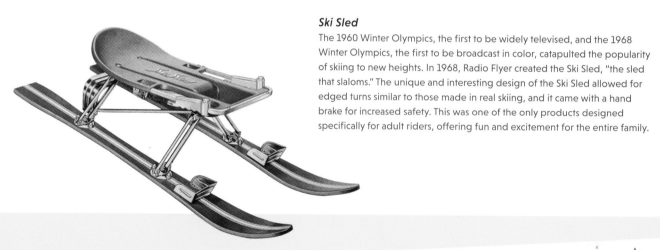

Ski Sled

The 1960 Winter Olympics, the first to be widely televised, and the 1968 Winter Olympics, the first to be broadcast in color, catapulted the popularity of skiing to new heights. In 1968, Radio Flyer created the Ski Sled, "the sled that slaloms." The unique and interesting design of the Ski Sled allowed for edged turns similar to those made in real skiing, and it came with a hand brake for increased safety. This was one of the only products designed specifically for adult riders, offering fun and excitement for the entire family.

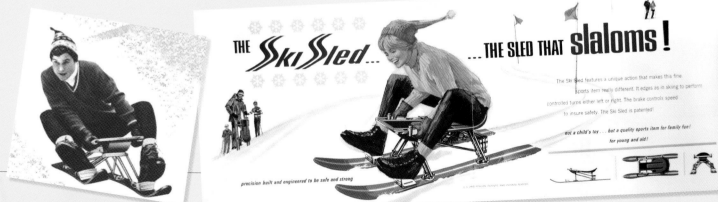

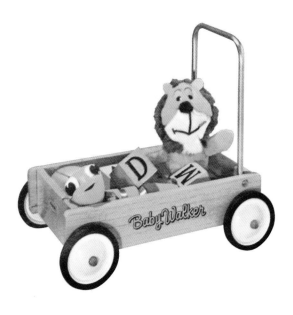

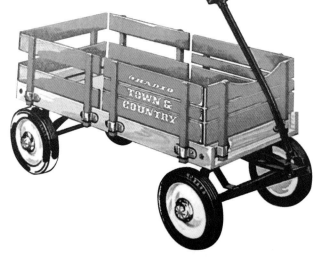

Baby Walker

While Neil Armstrong took one small step for man, Radio Flyer introduced a new wagon designed to help small children take their first steps. The Baby Walker provided storage, exercise, and unlimited types of play for some of the smallest customers.

Town & Country

First introduced in the 1960s, the Radio Flyer Town & Country became the best-selling wagon for decades. Its rugged and traditional wood design had a down-on-the-farm feel that kids loved. Its features put safety right up front, including smooth, streamlined corners and a controlled turning radius that guarded against tipping and provided a quiet ride.

Fireball 2000

Radio Steel & Manufacturing looked to American muscle cars for inspiration for the Fireball 2000, which debuted in 1970. With a rear spoiler, large back tires, and bright colors, the Fireball 2000 showcased Radio Flyer's commitment to classic quality and modern innovation.

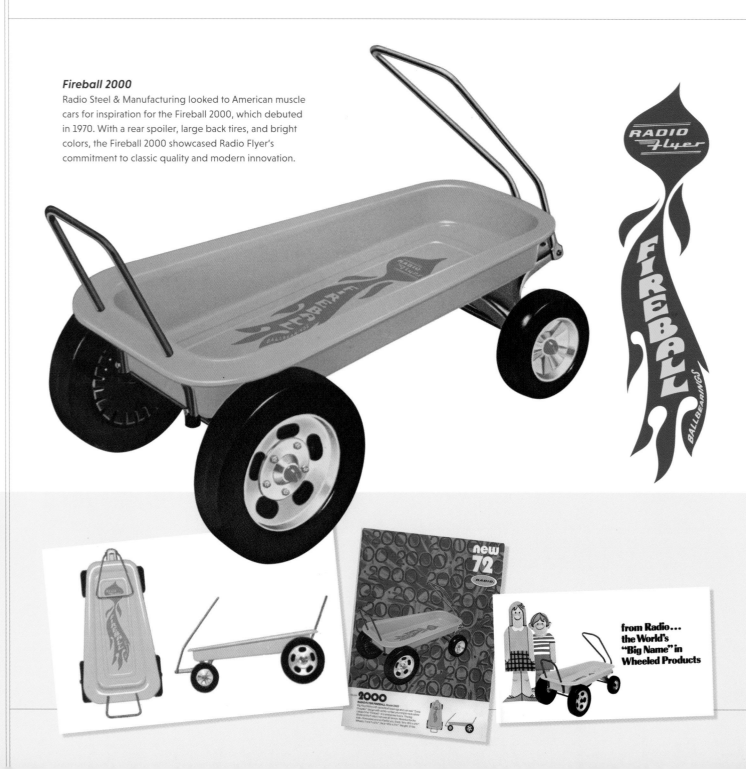

Tiny-Tot

The smallest of the time-honored line, the Tiny-Tot featured all of the design and functional elements of its larger companions packed into one smoothly rounded, toddler-friendly, compact body measuring sixteen by nine by two inches.

Motocross Tricycle

Throughout the 1960s and '70s, Motocross and other off-road riding sports exploded in popularity in the United States. Another sleek, and radical, design shift for the company was the Motocross Tricycle, which combined a unique body structure with safety features such as spokeless wheels, hand grips, and a wider wheel base for added stability.

Playloader

With construction booming in the 1980s, Radio Flyer created its own homage to big yellow construction equipment. The brightly colored Playloader featured construction-styled sides, deep-tread tires, and a simulated rear differential and shocks.

Hot New Wheels

As a part of strengthening Radio Steel & Manufacturing's reputation for dependability and lifelong loyalty to its customers, the company came out with a new line of wheels and replacement parts to keep customers' standard Radio Flyers and other products rolling for the next generation.

Radio Flyer rolls out new Playloader

A CENTURY OF SMILES
RADIO FLYER STORIES

Our two boys, Bill and John, had a dad who was in the navy in World War II. We lived in a small cabin and it mattered little that we had no car, as gasoline was severely rationed. This was Saint Patrick Street in Rapid City, South Dakota, in 1945.

Since I walked wherever I went, I wanted a wagon, as carrying a child in each arm balanced on my hip was too difficult. But it was wartime and there was no metal to make new Radio Flyers. So I walked the residential area of Rapid City looking into people's yards. If they had a wagon, I stopped and asked if they had children to use the wagon. After many days of fruitless searching I found a red Radio Flyer! The children who had used it were grown, so the lady sold it to me for five dollars. It was a little rusty, but otherwise in dandy shape.

What a help that wagon was! The boys loved to go with me down to the mailbox to see if there was a letter from Dad. It was about a quarter mile to the mailbox and one and a half miles to downtown. I was twenty-one years old and full of energy, so we had many happy trips. Bill would pat the side of our Radio Flyer and say, "Get up, Horsey!" and John would burst into giggles as I walked faster. The wagon even had some room for groceries and necessities. We had a total of five children who loved taking turns riding and pulling the red wagon.

It held up well and even lasted for our first grandson. When the Radio Flyer had to be retired, I planted it with moss roses and it graced the railing of our front porch. Strangely enough, the name Radio Flyer still showed plainly on its side. After so many years of happy use, it was practically a family member! I am now seventy-four, with ten grandchildren and five great-grandchildren, but I'm grateful for the happy memories recalled by thinking about our red Radio Flyer.

— S. DAVIS S. • Rapid City, SD

My Radio Flyer was my liberator. In 1955, a girl was taught what she couldn't be or do. But my Radio Flyer said, "Can too!" It taught me to work hard for what I wanted. You can't soar down a hill if you don't trudge up it first! Wrecks taught me to deal with adversity, make repairs, and move on. After I insisted the boys let me compete in their races, Dad starting calling it my "suffragette wagon." It taught me I could compete successfully—and equally—with anyone.

— RONNI F. • Buffalo, NY

FLYING
into a NEW
CENTURY

Radio Flyer Website

www.radioflyer.com

> *"Every boy and girl ought to have a little red wagon that can pull along a kid brother, a kid sister, a heavy load, a dream."*
>
> — GENERAL COLIN POWELL

THE 1990S WERE MARKED BY A SPIRIT of innovation and change that was everywhere—and accelerating—from the rise of the World Wide Web and wireless phones, to the shift from an analog to a digital information culture, to the influx of big-box retail stores. The Mall of America opened in Minnesota and national chains like Toys "R" Us and Walmart reached their peak in popularity as consumers around the country began shopping for their toys and goods in commercial strips that were all remarkably similar.

Now, in the twenty-first century, innovation that was once unimaginable has become everyday. We carry powerful computers in our palms, and the Internet connects our homes, phones, and cars. Apps allow us to order food and get rides from anywhere. A sharing economy has changed how we work and how we travel. Everyone is talking about robots, and cars are close to driving themselves. Just as the automobile and the airplane revolutionized transportation in Antonio's era, computers, phones, and the cloud have changed forever the ways we communicate and relate to one another.

Opposite: The first Radio Flyer website launched in 1997.

This growth and expansion was not missed by Radio Flyer. The 1990s and early 2000s brought big change to the company, and Radio Flyer did its own innovating during this time. The company released its first-ever ride-on plastic wagon in 1994. By the end of the 1990s, Radio Flyer was leading the industry in plastics, topping sales at Toys "R" Us. The little red wagon had cemented its place in history as an American icon.

As in previous eras, Radio Flyer did not sit on the sidelines but embraced the innovation of the times. Today, despite vast cultural changes, the company espouses the same values, believing that business is about more than products and profits—it's about the power of people to work toward achieving something meaningful together. Antonio's legacy lives on: The company, under the guidance of his grandson, still places extreme importance on how it treats its workers, and strives to build a workplace culture centered around fun and meaning. For this, in 2015, Radio Flyer was named *Fortune*'s #1 Best Small Business Workplace and one of *Inc.*'s 5000 Fastest-Growing Companies in America.

RADIO FLYER CELEBRATES ITS EIGHTIETH BIRTHDAY

I N 1997, RADIO FLYER CELEBRATED ITS eightieth anniversary. The celebrations began with Radio Flyer rolling out the World's Largest Wagon, a real working wagon that made the *Guinness World Records* and was featured on news shows and in headlines across America. This second not-so-little red wagon, designed to pay homage to Antonio's legacy, was inspired by the fifty-foot-tall Coaster Boy wagon display Antonio Pasin had created for the 1933 World's Fair—only this one was nine times larger than the original.

The gigantic fifteen-thousand-pound wagon was rolled onto a stage at that year's Toy Fair in New York City, and unveiled at the Hudson Theater in New York's Times Square for the event. It was then moved to Madison Square Park and set in front of the International Toy Center building, where it captured media attention, including coverage from CNN and *Late Night with Conan O'Brien,* and became a photo op for pedestrians who passed by. After the fair, the wagon was moved to company headquarters in Chicago, where it remains displayed today.

> *"Pasin's Little Red Wagons have hauled more cargo than any other child-powered vehicle in American history and have become American icons."*
>
> —TOY INDUSTRY FOUNDATION

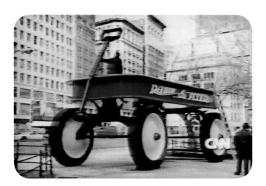

Above: The World's Largest Wagon, featured on CNN while parked in Madison Square Park in New York City for the 1997 Toy Fair.

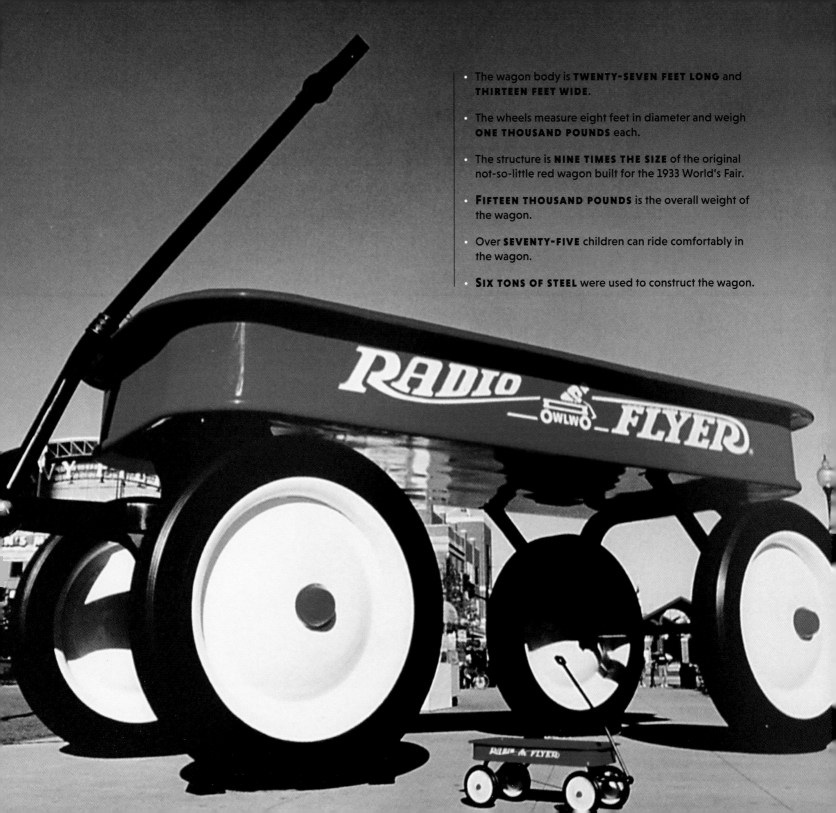

- The wagon body is **TWENTY-SEVEN FEET LONG** and **THIRTEEN FEET WIDE**.

- The wheels measure eight feet in diameter and weigh **ONE THOUSAND POUNDS** each.

- The structure is **NINE TIMES THE SIZE** of the original not-so-little red wagon built for the 1933 World's Fair.

- **FIFTEEN THOUSAND POUNDS** is the overall weight of the wagon.

- Over **SEVENTY-FIVE** children can ride comfortably in the wagon.

- **SIX TONS OF STEEL** were used to construct the wagon.

ANTONIO PASIN *in the* TOY INDUSTRY HALL *of* FAME

IN 2003, ANTONIO PASIN WAS POSTHUMOUSLY INDUCTED BY THE TOY Industry Foundation into the Toy Industry Hall of Fame for his preeminent role in the growth and development of the American toy industry. Antonio was recognized especially for having adopted the mass-production techniques of the auto industry to create his affordable, and revolutionary, steel wagons. Antonio was inducted alongside forty-one of the most notable toy makers of all time from around the world, including A. C. Gilbert (inventor of the Erector Set), Charles Lazarus (founder of Toys "R" Us), Frederick August Otto Schwarz (founder of toy retailer FAO Schwarz), George Lucas (director of the Star Wars franchise), and Walt Disney.

Above left: The Pasin family attends the banquet for Antonio's posthumous induction into the Toy Industry Hall of Fame in 2003. *Above right:* Antonio's wife, Anna, attends the event at the Waldorf Astoria with her family, where a video was played of her talking about her late husband's passion for creating wonderful toys for children.

A CENTURY OF SMILES
RADIO FLYER STORIES

We adopted our daughter HJ from South Korea when she was one and a half years old. Soon after she arrived, my husband got her a two-seater Radio Flyer red wagon with the seats that fold down. From that day on, HJ and her wagon were pretty much inseparable. We used the wagon to help her go to sleep when she was still adjusting to her new nighttime routine. We used it to stroll around the park, take HJ to a summer concert, bring her trick-or-treating for the first time. Fast forward to today, and seven-year-old HJ and her little sister Lila still ask Daddy to pull the red wagon around the neighborhood. It seems that some things never change, and sometimes you just don't want them to because the memories that they bring are so wonderful.

—ANGIE B. • Chicago, IL

—RACHEL A. • Baton Rouge, LA

Nineteen years ago, we adopted our now twenty-six-year-old daughter. She is severely handicapped with cerebral palsy. Although the entire family has always helped in the care of our Missy, my son Blake, now twenty-nine, was Missy's true buddy. I will always remember how he would load her in our Radio Flyer wagon and take her around the block so she could sit for hours and watch him play ball with his friends. The Radio Flyer wagon gave her a window to the world, and a place by her brother's side.

—GAYLE H. • Mundelein, IL

ALL-NEW WAYS TO RIDE

Pathfinder Wagon

In 1994, Radio Flyer released the company's first-ever plastic wagon, the Model No. 2100 Push Pull Wagon, which could go from push mode to pull mode in seconds without any hardware. The team continued to work on the designs until they had a plastic wagon that was truly one-of-a-kind in the market—and the Pathfinder wagon was born. Complete with foldable seats, seat belts, and cup holders, the Pathfinder became Radio Flyer's best-selling wagon.

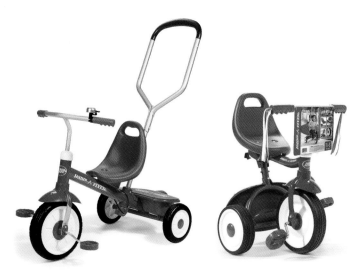

Radio Flyer Tricycle

This multi–award-winning tricycle was introduced in 1999 to much success. The retro Model No. 33 tricycle took design dies from the Liberty Coaster model of the 1920s. With chrome handlebars, streamers, a big shiny bell, and the sturdy steel construction Radio Flyer is known for, this tricycle became an instant classic.

Deluxe Steer & Stroll Trike and Fold to Go Trike

Radio Flyer had families on the go in mind when they created the Deluxe Steer & Stroll Trike and Fold to Go Trike. The Deluxe Steer & Stroll Trike allowed adults to turn the front wheel with the rear push handle, while the Fold to Go Trike's folding function made storage and portability simpler.

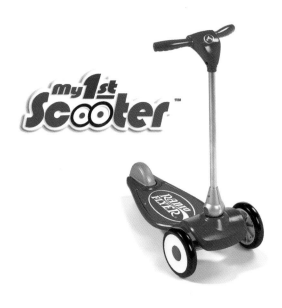

My First Scooter

After observing how little kids ride scooters, Radio Flyer launched a new kind of scooter: one with two wheels in front, for maximum stability for beginner riders. It became the best-selling preschool scooter on the market soon after it was launched.

Ziggle Ride-On

With the Ziggle, Radio Flyer introduced a whole new way to ride. It was propelled by twisting the front and wiggling the back at the same time. This created a wider range of movement, with more advanced riders able to drift into 360-degree spins.

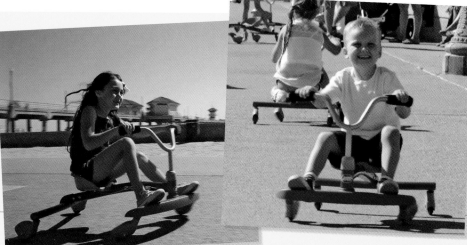

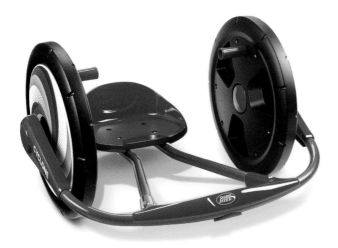

A CENTURY OF SMILES

RADIO FLYER STORIES

Cyclone

Using arm-powered action, riders can spin the Cyclone 360 degrees for unlimited fun. Whether zooming forward or rolling in reverse, the sixteen-inch wheels offer a smoother ride. The Cyclone features comfort handgrips and a solid-steel frame.

The picture is of my grandparents, who lived on an old farm in rural Alabama. At the time this picture was taken, Grandfather was in his nineties and Grandmother in her eighties. They were still very active and living on their own on their farm. Grandfather used a wagon to haul sacks of feed. I remember coming to visit as a child and riding that wagon down the hill in front of the old farmhouse. Over the years, the old wagon he used got worn out, so on Christmas, someone in the family gave him a new wagon. This is a picture of him taking his "girl" for a ride in his new red wagon.

— SCOTT H. • Mobile, AL

CUSTOMIZE MY RIDE

WITH MORE AND MORE RETAIL moving online in the early 2000s, many companies gained the ability to sell their products directly to consumers for the first time, without traditional retailers acting as intermediaries. In 2010, RadioFlyer.com, which was originally launched in 1997, expanded to offer its products direct to customers online. While this would be enough for most toy companies, Radio Flyer looked to some of the top companies outside of the toy industry for ways to take it a step further.

Radio Flyer observed the trend of companies giving customers more ways to customize and personalize their products when ordering them online. Radio Flyer decided to build out its own capability to offer

Above: A little girl takes her stuffed animals for a ride in the family's custom wagon. *Below*: Some of the dozens of options available through the Build-A-Wagon program.

customers high-end customizable products. Inspired by websites such as NIKEiD, which lets customers personalize their shoes and accessories down to every detail, RadioFlyer.com's Build-A-Wagon program allows customers to create their own customized, personalized wagons, trikes, and scooters. After a hundred years of design innovation and creativity—and few choices other than red—customers can now choose from a variety of colors, and add anything from cushions to speakers to (most popular of all) personalized nameplates to their toys. The whole program is designed to give customers a high-touch experience from end to end, with each individual product made specially for them and shipped directly to their home, complete with a certificate of authenticity.

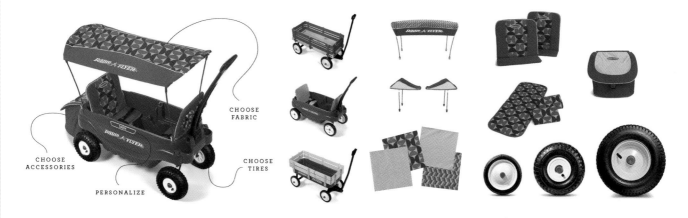

CHOOSE FABRIC

CHOOSE ACCESSORIES

CHOOSE TIRES

PERSONALIZE

A CENTURY
OF SMILES
RADIO FLYER STORIES

Shortly before her second birthday, our daughter Rebekah required major abdominal surgery. Although the operation was a success, she would not eat or drink until a visit was arranged with her brothers. During her recovery at home, the boys noticed many children with wagons. They insisted Rebekah needed a wagon, too. The surgery is behind us now and the painful memories are fading, but I will always cherish the day three big brothers took turns, proudly pulling their little sister in her new Radio Flyer wagon.

—BONNIE SUE B. • Newton, NJ

—JULIE D. • Plano, TX

HACK MY RIDE: CUSTOMERS REMIX

RADIO FLYER IS ALWAYS COMING UP WITH NEW IDEAS . . . BUT SO ARE ITS customers. Whereas before, Radio Flyer grew to be a part of the cultural zeitgeist through its appearance in movies and TV shows, by the 2000s, Radio Flyer's classic little red wagon had become the subject of its customers' own innovations. Loyal fans transformed their beloved wagons into all-new creations—all without Radio Flyer's input. A look at some of the most innovative—and outrageous:

Above: Radio Flyer fans invent their own Radio Flyer-inspired creations, ranging from a fully functional motorized go-kart, to a vintage car, to a side table, to a giant wagon.

STAYING POWER

WITH TODAY'S RENEWED INTEREST in authenticity and products that represent a classic America and homegrown enterprise—from bringing back craft breweries to old records and retrofitted typewriters—younger generations are adapting the Radio Flyer wagon into their own modern novelties. Little red wagons are being used to create flower boxes, bookshelves, clocks, coffee tables, desks, towel bars, toy chests, and even ice coolers, which their makers proudly post online!

While Radio Flyers have evolved with the times, for many, they still retain their utilitarian purpose. Just ask anyone on Fire Island, a bit of land off Long Island where there are no cars—but lots of little red wagons. In a place where you walk everywhere, wagons, which are kept at the harbor for easy access upon arrival, are a way to transport luggage, groceries, and more.

Above: Radio Flyer wagons on Fire Island, New York, where they are used to cart luggage, little kids, and supplies around town.

THE COMPANY BEHIND THE WAGON

All in the Family

RADIO FLYER HAS REMAINED A FAMILY company for three generations. By the year 2000, Mario had turned the reins over to his sons, Robert and Paul, the third generation of the Pasin family to lead the company.

Above: Mario Pasin (right) and his sons Robert (left) and Paul (middle), who represent the third generation of the Pasin family to lead the company. *Right:* Antonio (right) and his son Mario (left) around the time Mario took over leadership of the company, circa 1970.

Design Innovations

THE COMPANY'S PASSION FOR DESIGN THAT BEGAN more than a hundred years ago with Antonio's attention to detail, obsession with quality, and love of beautiful things continues to permeate everything Radio Flyer does today. Today's "craftspeople," Radio Flyer's designers and engineers, apply Antonio's attention to detail to a wide variety of materials, using the latest manufacturing methods to build vehicles that inspire classic, good clean fun.

Whereas before, the company's designs were determined by Antonio himself sitting at a table with a pencil and paper, today Radio Flyer boasts a design team that represents roughly a third of the company's employees. Radio Flyer's headquarters feature an in-house prototyping shop and state-of-the-art design software and materials that aid designers in bringing their ideas to life: 3-D printers use the designers' Computer-Aided Design (CAD) drawings to cut initial protoypes out of plastic and foam. Prototypes are then taken to the "Play Lab" and "Test Track," where kids play with the toys and designers can learn how the kids naturally want to ride around. This iterative style of prototyping and testing is repeated again and again, until the design team knows they have a winning product.

And the Award Goes To . . .

CHICAGO
INNOVATION
AWARDS
2007

BY THE EARLY 2000S, RADIO FLYER WAS LEADING THE way in plastic wagon and trike innovation. The Ultimate Family Wagon included a sunshade canopy and five-way flip-and-fold seats. This design ingenuity earned the company a Chicago Innovation Award in 2007.

Top and Middle: Designers and engineers utilize the Prototype Shop and state-of-the-art tools to bring innovative concepts to life. *Above:* Radio Flyer has been the recipient of multiple Chicago Innovation Awards, including the 2007 award for the Ultimate Family Wagon.

Historic Headquarters Get a New Lift

IN 2017, RADIO FLYER COMPLETED A renovation of its historic headquarters building in Chicago—and made history again. The project, which has geothermal heating and cooling, water-efficient native landscaping, and day-to-day sustainable practices supported by an internal committee (the "Eco Flyers"), is one of Illinois's few LEED Platinum-certified buildings. (LEED is an internationally recognized sustainability certification system.) New open workspaces are equipped with sit-to-stand desks with maximum access to natural light, and a gallery display connecting today's new products with the company's hundred years of history.

Above: Today's entrance to Radio Flyer's main office and headquarters—the spot that the World's Largest Wagon calls home when it is not rolled out for special occasions.

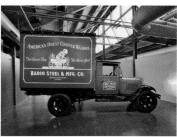

Upper left: Since the 2017 renovation, employees work together in an open office plan, complete with sitting areas, lots of natural light, and Radio Flyer art! *Lower left:* The Heritage Gallery, where employees and visitors can walk through a century of Radio Flyer's products and growth as a company. *Top:* Hanging wagons on a conveyor belt above the main workspace are reminiscent of the company's production lines in the 1930s. *Above:* A re-creation of the original Radio Steel & Manufacturing Company delivery truck from the 1930s.

Values Are Timeless

THE ETHOS AND MISSION OF RADIO FLYER have remained the same in spirit ever since Antonio first wrote the slogan "For every boy. For every girl." In 2004, the company sat down to formally outline its core vision, mission, and values. It was a yearlong process that invited every employee to participate by sharing what it meant for them to work at Radio Flyer.

The Radio Flyer team looked back over the course of the company's history, and asked questions such as "When you say you work at Radio Flyer, what do you say and how do people respond?" They found many employees had similar answers: The first thing most people do when they hear the words "Radio Flyer" is smile. Then they tell a story from their childhood, or about their own children. From this came the articulation of the company's vision, mission, and values:

VISION: To be the world's most loved children's brand.

MISSION: To bring smiles to kids of all ages and to create warm memories that last a lifetime.

By our actions:

R elentless commitment to build a great team.

A wesome kids' products that inspire active play.

D eliver breakthrough results.

I mprove our world by acting sustainably.

O utstanding Little Red Rule customer service.

VALUES: We follow the Little Red Rule: Every time we touch people's lives, they will feel great about Radio Flyer.

We live the Flyer Code:

F UNomenal Customer Experiences

L ive with Integrity

Y es I Can

E xcellence in Everything

R esponsible for Success

RADIO FLYER *by the* **NUMBERS**

#1 *worldwide producer of* **WAGONS & TRIKES**

The **3**rd Wednesday of March is National Little Red Wagon Day

10,000+ *stores sell Radio Flyer products*

more than **100** **MILLION** **WAGONS** *have been sold to date*

A CENTURY
OF SMILES
RADIO FLYER STORIES

— TRACEY C. • Long Beach, CA

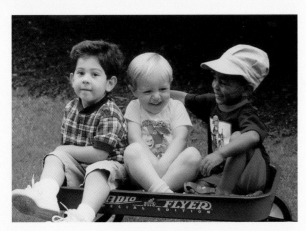

This photo is special to many people because all three boys are three years old in the picture and, most important, all three are adopted children. On this day, they were celebrating Jordan's birthday. He had just gotten the wagon from his parents. Alex (far right) got a wagon for Christmas, just like his best buddy Jordan's!

— DIANA A. • Spokane, WA

— SYBLE B. and SHAQUANSHIA J.
• Tulsa, OK

147

RADIO FLYER
on the SILVER SCREEN

TAKING FLIGHT IS AN EMMY-WINNING short animated film inspired by the life and heritage of Antonio Pasin, inventor of the Radio Flyer wagon. In this fictional tribute to the founder's legacy, what begins as a small boy's overscheduled, oversupervised, boring day with Grandpa turns into a larger-than-life journey—narrowly escaping wild monkeys and battling aliens to save the universe. Through the power of imagination and epic adventure, a boy learns to be a kid, a father learns to be a dad, and a grandfather reminds us all what childhood is about.

Above: The Emmy trophy presented to Robert Pasin at the 2017 Emmy Award ceremony. *Right:* Stills from the Emmy Award–winning short film *Taking Flight*.

Taking Flight

A MOONBOT STUDIOS FILM
DIRECTED BY BRANDON OLDENBURG
TAKINGFLIGHTFILM.COM

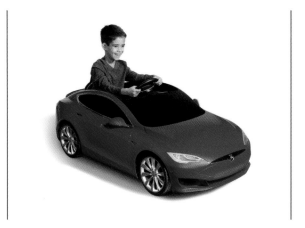

FLYING INTO THE FUTURE

THERE'S A NEW VEHICLE ON THE open road: the Tesla Model S for Kids by Radio Flyer!

Today, Radio Flyer continues to respond to new technologies and look ahead to be at the forefront of innovation and change. Inspired by advances in the automobile industry, Radio Flyer studied battery-operated cars for children, and wondered how it could evolve in that area. Families that had these toys were often frustrated with the battery, which had consistent problems holding a charge. Through a partnership with the country's most advanced and sustainable auto company, Tesla, in 2016 Radio Flyer launched the first and only ride-on for kids to use Flight Speed lithium ion batteries. Like the grown-up cars, the kids' cars were designed to provide the best performance with a lower impact on the environment, the longest run time, and the fastest recharge time. The result—the Model S for Kids—became the first customizable kids' car on the market and the latest in a line of vehicles that inspire exploration, imagination, and fun.

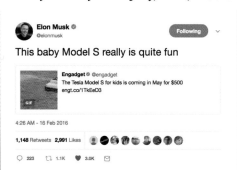

Top and Opposite: A young boy and girl enjoy their new Tesla Model S for Kids! *Above:* A tweet from Tesla founder Elon Musk in February 2016.

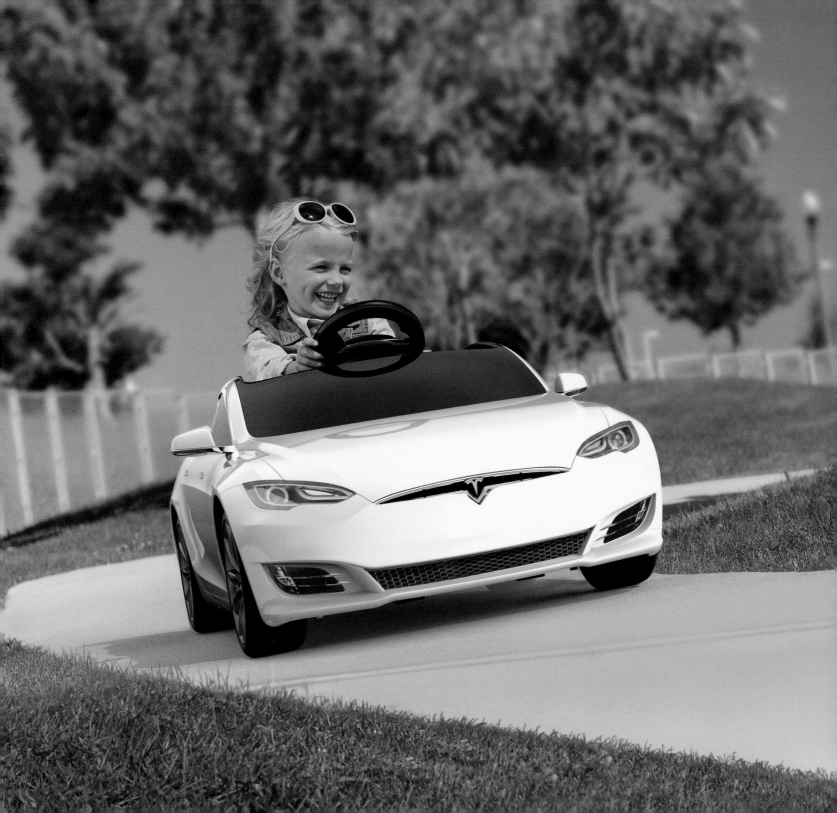

A CENTURY OF SMILES

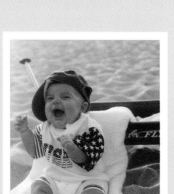
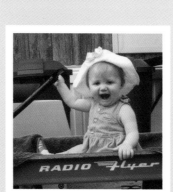
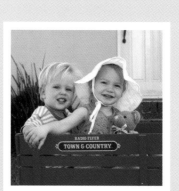
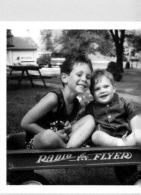

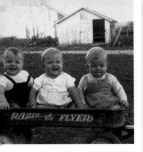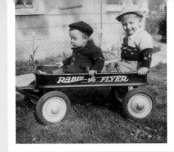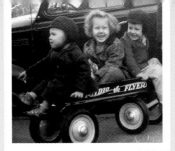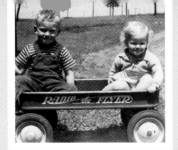

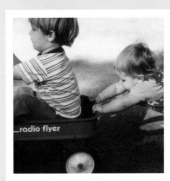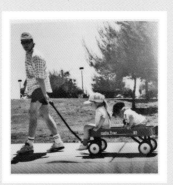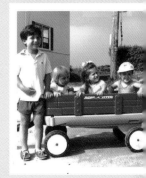

Radio Flyer holds a special place in people's hearts because it transports them
to the best parts of childhood, to a time of play, laughter, imagination, and love.
It takes them to a place where anything is possible.

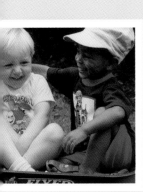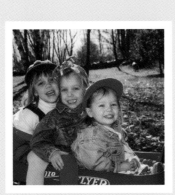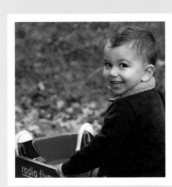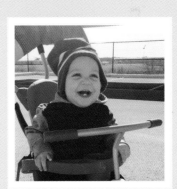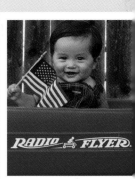

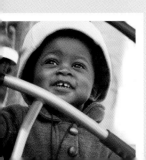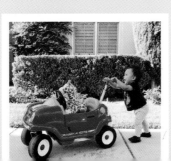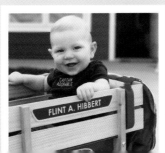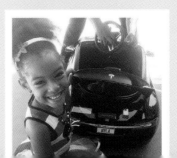

CONCLUSION

TIME FLIES—ENJOY THE RIDE

THEY SAY HISTORY REPEATS ITSELF, and in Radio Flyer's long life as a company, that has certainly proven to be true. In fact, many parallels have emerged between the era when Antonio Pasin started Radio Flyer and our own whirling modern era. In 1917, America was in the throes of a war and on the brink of some of the most progressive and disruptive political and social periods in its history. Today, there is a similarly heightened pace of innovation and disruption of old ways, and the world of only a decade or two ago seems so different.

In 2017, Radio Flyer celebrated its hundredth birthday. On September 28, five hundred people gathered at Radio Flyer's newly renovated headquarters to celebrate one hundred years of innovation and memories. The company rolled out the World's Largest Wagon on Michigan Avenue and the mayor of Chicago, Rahm Emanuel, delivered a keynote address. The memory-making event was covered by local and national news, including the *New York Times,* the *Washington Post,* and the AP.

For the past hundred years, Radio Flyer's products have served to spark imagination and to make memories. The original little red wagon has linked generations of families—not only the Pasins, but also the millions of customers who have loved and lived with their Radio Flyers. A century after Antonio Pasin came to America and started tinkering in his garage, his ideas, offerings, and inspiration are still as relevant as ever.

The story of Radio Flyer reflects the melting pot that is America, and illuminates the benefits of welcoming foreigners to our shores. At the time Antonio came to Ellis Island, one-third of Italy's people had left their country in search of better living conditions.

Innovations contributed by immigrants continue to be the backbone of American industry today. Two out of every five Fortune 500 companies, including many of our most "American" companies—Apple, General Electric, and McDonald's—were founded by immigrants or their children. According to the Kauffman Foundation,

Above and Opposite: Radio Flyer commemorates its hundredth anniversary with its very own birthday celebration for all of its close family and friends. The party was complete with a live jazz band and dance group, a feature film that showcased Radio Flyer through the century, and a very large birthday cake.

almost half of the technology companies started in Silicon Valley had a foreign-born founder. It is not just Silicon Valley: One-quarter of high-tech startups have an immigrant founder (even though foreign-born individuals make up only an eighth of the U.S. population). International workers are named on about a quarter of U.S. patents and historically receive up to a third of Nobel Prizes.

For the past hundred years, Radio Flyer has benefited from the promise, and delivery, of the American Dream. The next hundred years, like the past, will bring many changes—advances and issues we cannot even imagine.

But imagination is everything. And it is boundless. It is not limited to an anointed few, but open to anyone brave enough to see things as they want them to be. It is in the hands of every Flyer who sees their wagon as a race car, their trike as a chariot, and their scooter as a spaceship. Radio Flyer is a vehicle of creativity. From yesterday, to today, to tomorrow, it can take you anywhere you want to go.

ACKNOWLEDGMENTS

IT IS RARE FOR A COMPANY TO BE IN business for more than a century, and it takes the efforts of many people over many years to accomplish something so special. There are many friends and colleagues who have taken this incredible ride with me. There is an old saying that sums this up, "We are standing on the shoulders of giants." I would like to thank some of those giants.

It is not possible to build a business without lots of vendors, partners, and customers. We have enjoyed many long-term relationships with so many great companies through the years. Thank you.

None of this would be possible without all of the people who have worked at this company through the years, and our team of FUNomenal Flyers today. I am so proud of our amazingly creative and committed team, and I'm so grateful for all of your excellent work.

As the youngest of five kids, I grew up in a house filled with love and laughter. My siblings were always incredibly kind and patient with their little brother who was often a big bother. I'm grateful to my brothers Mark and Tony for their contributions to Radio Flyer when they worked at the company. I'm appreciative

of my sister, Therese, who was always willing to lend me a hand in the business when we needed help. I'm so grateful to my brother Paul for our close collaboration through the years and his supportive partnership. The company would not be what it is today without him.

I would like to thank my mom and dad for being such amazing parents. Through your example, you taught me that of those to whom much is given, much is required. Dad, I want to thank you for your leadership and stewardship of Radio Flyer for so many years. I have learned much from you— especially about great design and quality, and most importantly, about always treating others with kindness and respect. None of us would be here today without you!

Thank you to my grandparents Antonio and Anna Pasin, immigrants who came to this country with so little and created so much. My grandma lived to the age of 107 and passed away peacefully in her home in 2016. She would often tell me that *Nonno* was looking down on me, our family, and everyone at Radio Flyer, and that he was so proud of us.

I want to especially thank my wife, Muriel, for being my best friend and the love of my life. I could not do any of this without

Above: Photograph of Anna and Antonio Pasin together circa 1930.

your amazing love and support. You also made four incredible kids for us.

This book was truly a labor of love, and it would never have happened without amazing writers Carlye Adler and Campbell Schnebly, who are brilliant and delightful to work with. A special callout to Campbell for the time she spent in the archives getting to know my grandfather and adding historical research that provided me with a clearer picture of his life and made this book stronger. Our book team also consisted of Mary Kate Venturini and Ellen Eide, who invested countless hours searching our archives and libraries for images that told a story. Thanks to my intrepid assistant, Julie Jackson, who serves as our unofficial company archivist.

Esteemed literary agent Jim Levine understood the vision for this book and found us the right publishing partner. Cristina Garces, our editor at Harper Design, and her team brought this book to life.

So many people have helped Radio Flyer on our journey. There is not enough room to list the countless names, but I hope you know who you are. I am eternally grateful to each and every one of you.

Finally, thank you to the millions of people who own a Radio Flyer product, and those who have heard their parents, or even grandparents, tell stories of their childhoods starring a little red wagon. Thank you for sharing your story. Thank you for being part of our story.

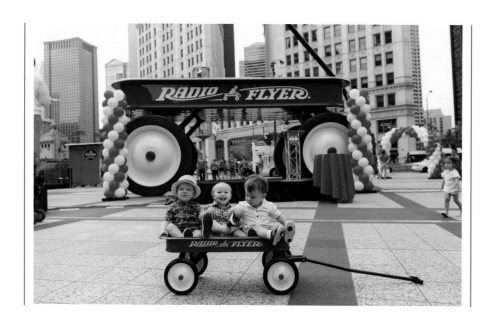

PHOTOGRAPHY CREDITS

All images © Radio Flyer Inc, with the exception of the following:

Page 16: Statue of Liberty in Black and White/via Pxhere.com

Page 18: Double indexed street map of Chicago/Fred Wild Company/via Wikipedia Commons

Page 30: View of Villa Giusti, near Padua, where armistice was signed between Italy and Austria-Hungary, World War I, from *Illustrazione Italiana*, Year XLV, No 46, November 17, 1918/ De Agostini/Biblioteca Ambrosiana/via Getty Images

Page 34: 1932 Great Depression Hooverville Home Central Park New York USA/ Charles Phelps Cushing/ClassicStock/via Getty Images

Page 35: Unemployed men queuing/Photo12/UIG/via Getty Images

Page 50: Lovell's Weekly Jig-Saw Puzzle/iStock.com/powerofforever/via iStock by Getty Images

Page 50: Scrabble Boardgame/iStock.com/lenscap67/via iStock by Getty Images

Page 50: A collection of jacks within the permanent collection of The Children's Museum of Indianapolis/The Children's Museum of Indianapolis/via Wikipedia Commons

Page 54: Aerial View of the Century of Progress International Exposition, Chicago/Chicago Aerial Survey/via Wikipedia Commons

Page 70: Postcard photo of the Pioneer Zephyr/Burlington Route/via Wikipedia Commons

Page 71: Chrysler Airflow, 1934/PhotoQuest/Getty Images/via Getty Images

Page 74: Female Factory Workers Rivet an Airplane, World War II/Lambert/via Getty Images

Page 75: Women examining shells at a factory/SuperStock/via Getty Images

Page 77: Crewmen of C-47 transport planes unload jerricans of gasoline for 3rd US Army tanks at an airfield near Frankfurt/Photo12/UIG/via Getty Images

Page 79: Boy Scouts Collecting Toy Train Roadbed/Bettmann/via Getty Images

Page 84: *Better Homes and Gardens*® (the "Magazine") March 1953: Image on page 53 from the article titled "Today's House Makes Good Sense" by John Normile, A.I.A./Meredith Corporation

Page 102: Civil Rights March on Washington, DC. Entertainment: closeup view of vocalists Joan Baez and Bob Dylan.], 08/28/1963/Rowland Scherman/via Wikipedia Commons

Page 103: Iconic toys thru the decades for the parenting special section, in Washington, DC./The *Washington Post*/Contributor/via Getty Images

Page 103: An Atari 2600 video game console, shown in all black/Evan Amos/via Wikipedia Commons

Page 104: Family watching television, c. 1958/Evert F. Baumgardner/via Wikipedia Commons

Page 128: Hewlett-Packard HP9000 Unix Workstation, Model 735-99, HP9000/735, Series 700, PA-RISC 7100 CPU - 32 Bit - 99 MHz, max 400 MByte RAM, HPUX 10.20, CDE, SCSI, HIL, HP A4033A 19 inch CRT/Thomas Schanz/via Wikipedia Commons

Page 141: Fire Island Ferry/Ezra Shaw/Getty Images/via Getty Images

Page 150: @elonmusk. "This baby Model S really is quite fun." Twitter, 16 Feb. 2016, 12:26 a.m., twitter.com/elonmusk/status/699510097332994048.

Acknowledgments for Radio Flyer images:

Page 23: Photography by Chris Cassidy

Page 26: Courtesy of Vicki Porter

Page 30: Courtesy of Linda Mounts

Page 31: Courtesy of Karen Funk

Page 32: Courtesy of Jennifer L.

Page 51: Courtesy of Carol Kistler

Page 51: Courtesy of Martha Dixon

Page 56: Courtesy of Thomas Itrich

Page 57: Courtesy of Thomas Anderson

Page 57: Courtesy of Laura Collins

Page 64: Photography by Chris Cassidy

Page 65: Two Images Courtesy of Robert Shellady

Page 65: Courtesy of Andrew Robb Jr.

Page 72: Courtesy of Dale Mikolash

Page 76: Photography by Chris Cassidy

Page 85: Courtesy of Ethel Young

Page 89: Courtesy of Barbara Dawn Meyer

Page 89: Courtesy of Patricia Lampariello

Page 108: Courtesy of Kathleen Wells

Page 109: Courtesy of Evelia Cardenas

Page 118: Courtesy of Brigid Anne Winn

Page 119: Courtesy of Michelle Pannell

Page 133: Courtesy of Rachel Alcock

Page 137: Courtesy of Scott Hassell

Page 138: Lifestyle Photography by Susan Andrews

Page 138: Product Photography by Chris Cassidy

Page 139: Courtesy of Julie Duncan

Page 139: Courtesy of Bonnie Sue Bastin

Page 147: Courtesy of Diana Anderson

Page 147: Courtesy of Tracey Clark

Page 147: Courtesy of Syble Beard & Shaquanshia Johnson

Page 148: Brandon Oldenburg in collaboration with Moonbot Studios

Page 151: Photography by Susan Andrews

About the Authors

ROBERT PASIN, grandson of the founder, Antonio Pasin, is the CWO (Chief Wagon Officer) of Radio Flyer Inc., maker of the famous and beloved little red wagon and the world's largest producer of wagons, tricycles, preschool scooters, and other ride-ons. Radio Flyer has more than 100 award-winning products available throughout the world. Since 1917, the family-owned company has created beautifully designed, high quality, timeless, and innovative toys that celebrate the best parts of childhood. In his time at the helm, Pasin has led a cultural transformation of the company, resulting in a dynamic, goal-oriented workplace that has received numerous awards and was named the #1 Workplace in the US by *Fortune Magazine*, a Top Small Workplace by the *Wall Street Journal*, and one of the 5000 Fastest-Growing Companies in America by *Inc*. Pasin is the Producer of the Emmy-winning animated short film, *Taking Flight*. He earned a Bachelor's Degree in History from the University of Notre Dame and an M.B.A. from the Northwestern University's Kellogg Graduate School of Management. Pasin lives in Oak Park, Illinois with his wife and four children and a backyard full of wagons, tricycles, and other ride-on toys.

CARLYE ADLER is an award-winning journalist and coauthor of many books, including four *New York Times* bestsellers. Her writing has been published in *BusinessWeek*, *FastCompany*, *Fortune*, *Forbes*, *Newsweek*, *TIME*, and *Wired*. She lives in Connecticut with her husband, two daughters, and a skateboarding bulldog. (He loves his Radio Flyer Wagon too.)